Captivating Castles

By

Leila Fernwood

No part of this book may be reproduced in any form and may not be stored or transmitted by any means, known now or developed in the future. The designs in this book are for personal use only and may be reproduced by the purchaser for that use.

You are free to share your finished colored pages as long as credit is given to the artist. No uncolored pages are to be shared or posted online.

All other uses, especially commercial use, are strictly forbidden without written permission by the creator, Leila Fernwood.

Copyright Leila Fernwood 2019

All Rights Reserved

ISBN: 9781793265012

Join **The Art of Leila Fernwood** on Facebook to share your pictures, get ideas from other colorists, and for free pages from my books.

Are you new to grayscale coloring? Don't be intimidated, it's easy. Instead of coloring within the lines, you color over the grayscale image. The grayscale adds shading to your coloring so you don't need to figure it out yourself. You can use one color over an area and see the grayscale shading add variation to that color. Many people pick 3 colors to color a section: the darkest on the heaviest gray (shadows), the lightest color on the lightest area (highlights), and the medium color over the rest of the section.

I encourage you to copy the images for your own personal use. This gives you a chance to try a variety of mediums and different types of paper to achieve the look you want.

When using markers, a piece of cardstock behind your page keeps colors from bleeding through. When using colored pencils, a lighter hand will let more shading show through.

Be creative, do it your way, and most of all, have fun!

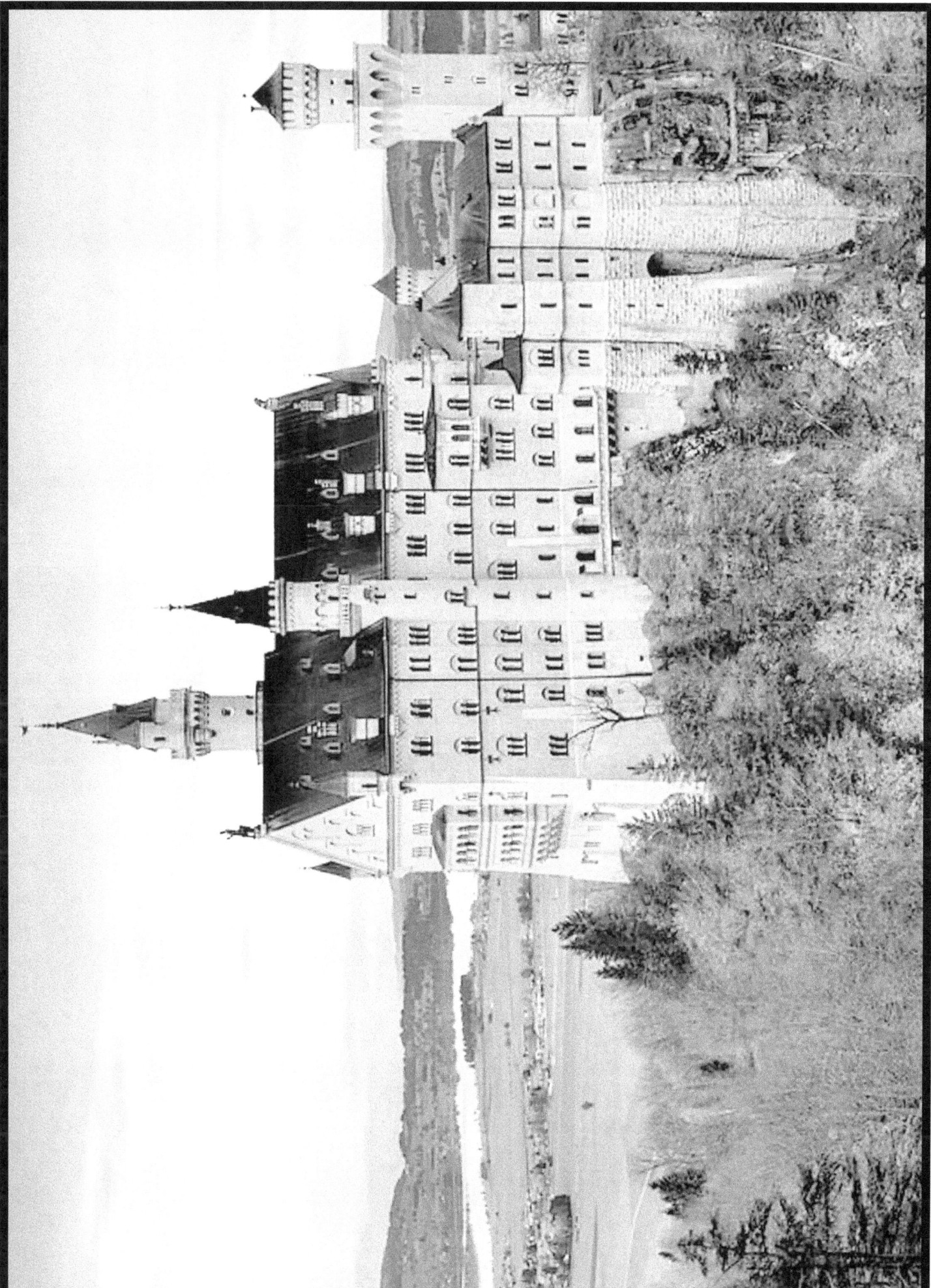

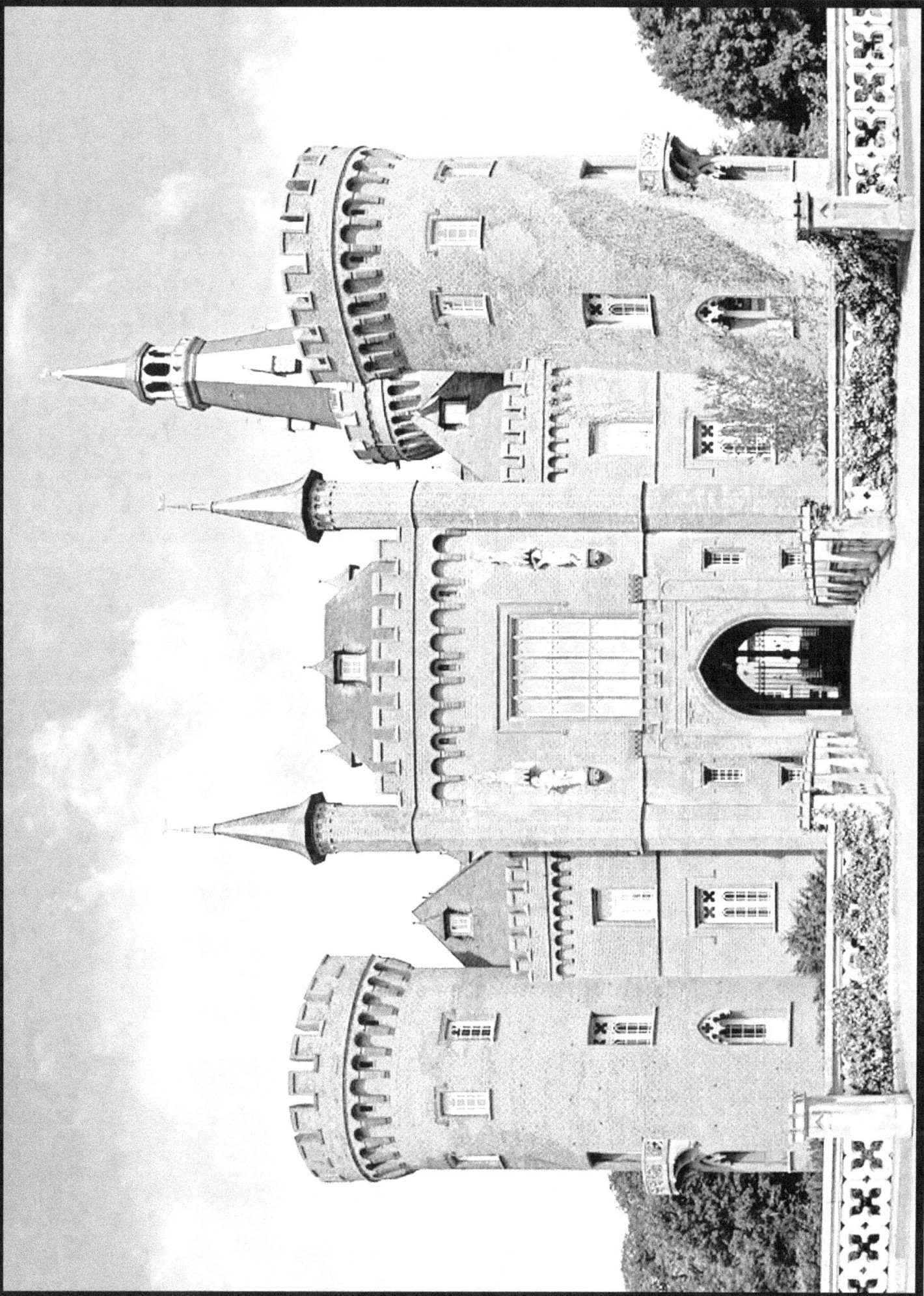

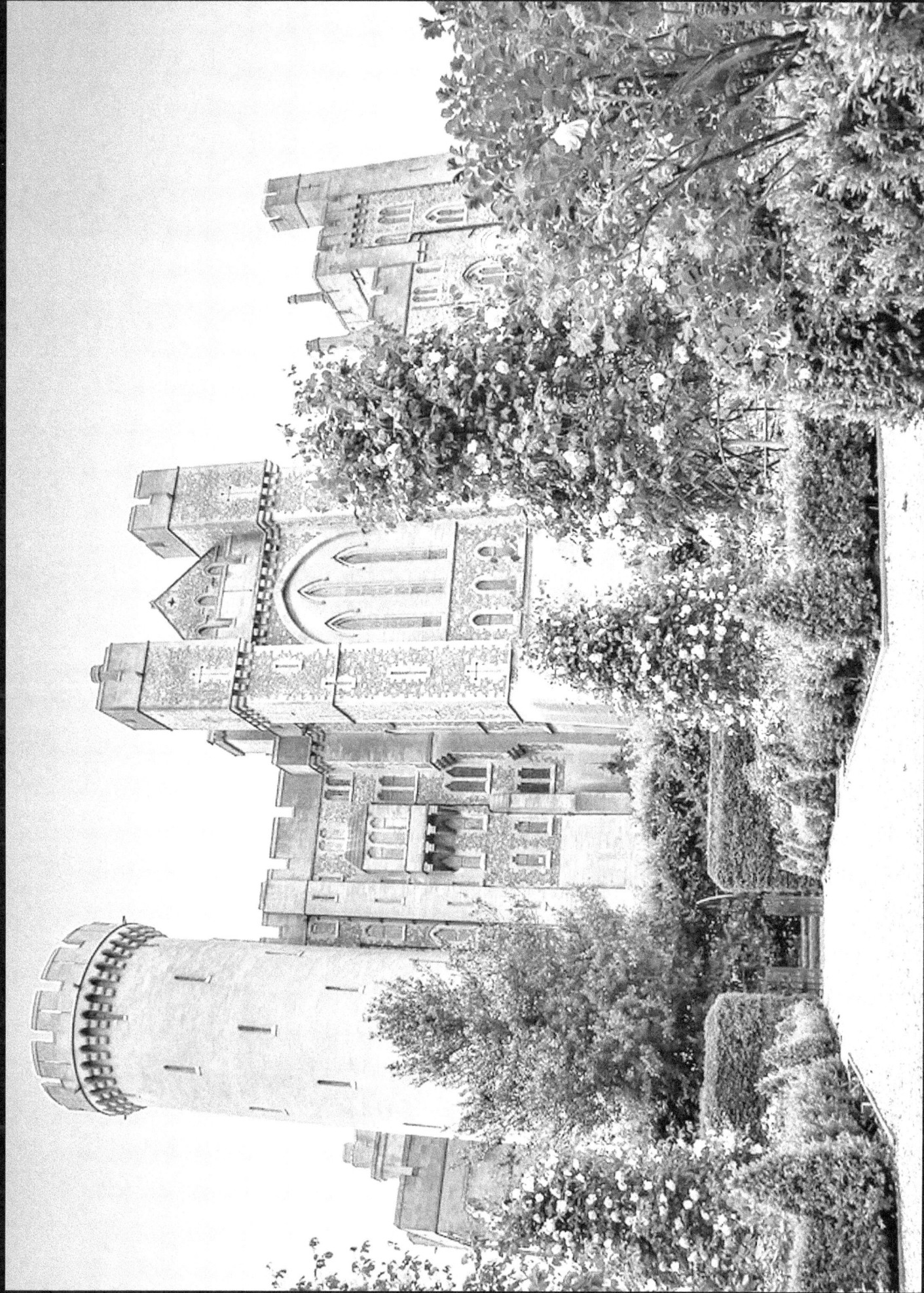

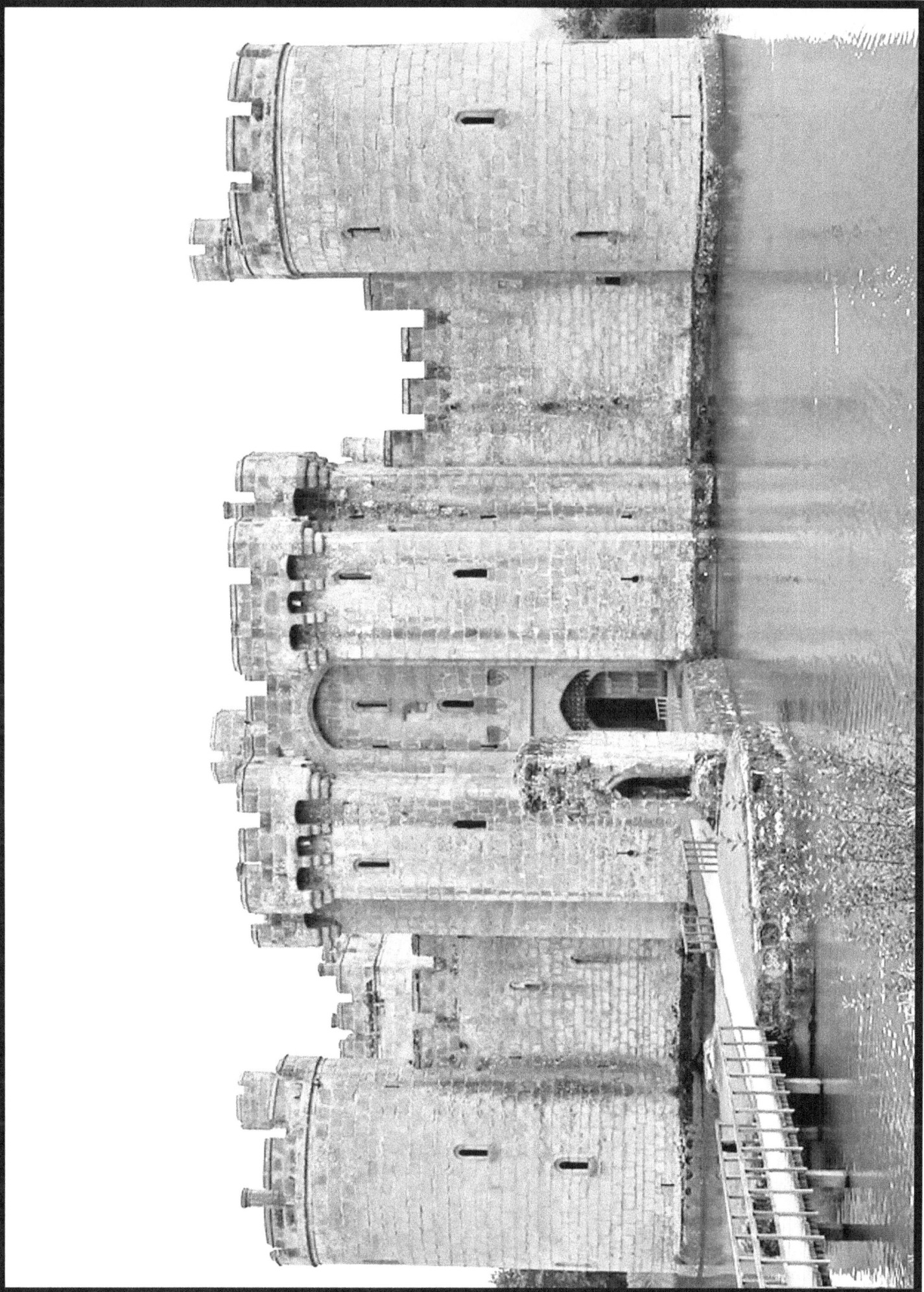

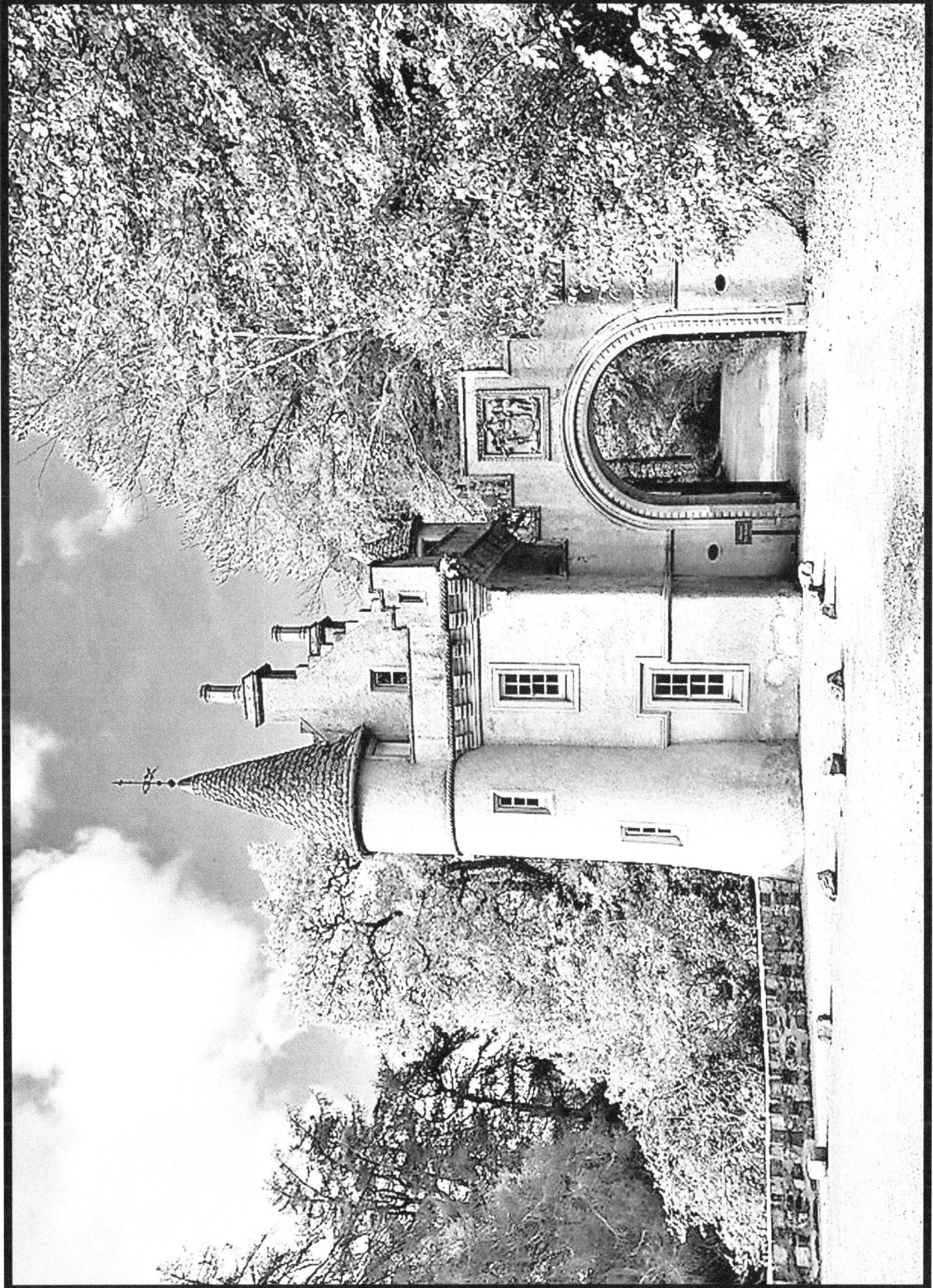

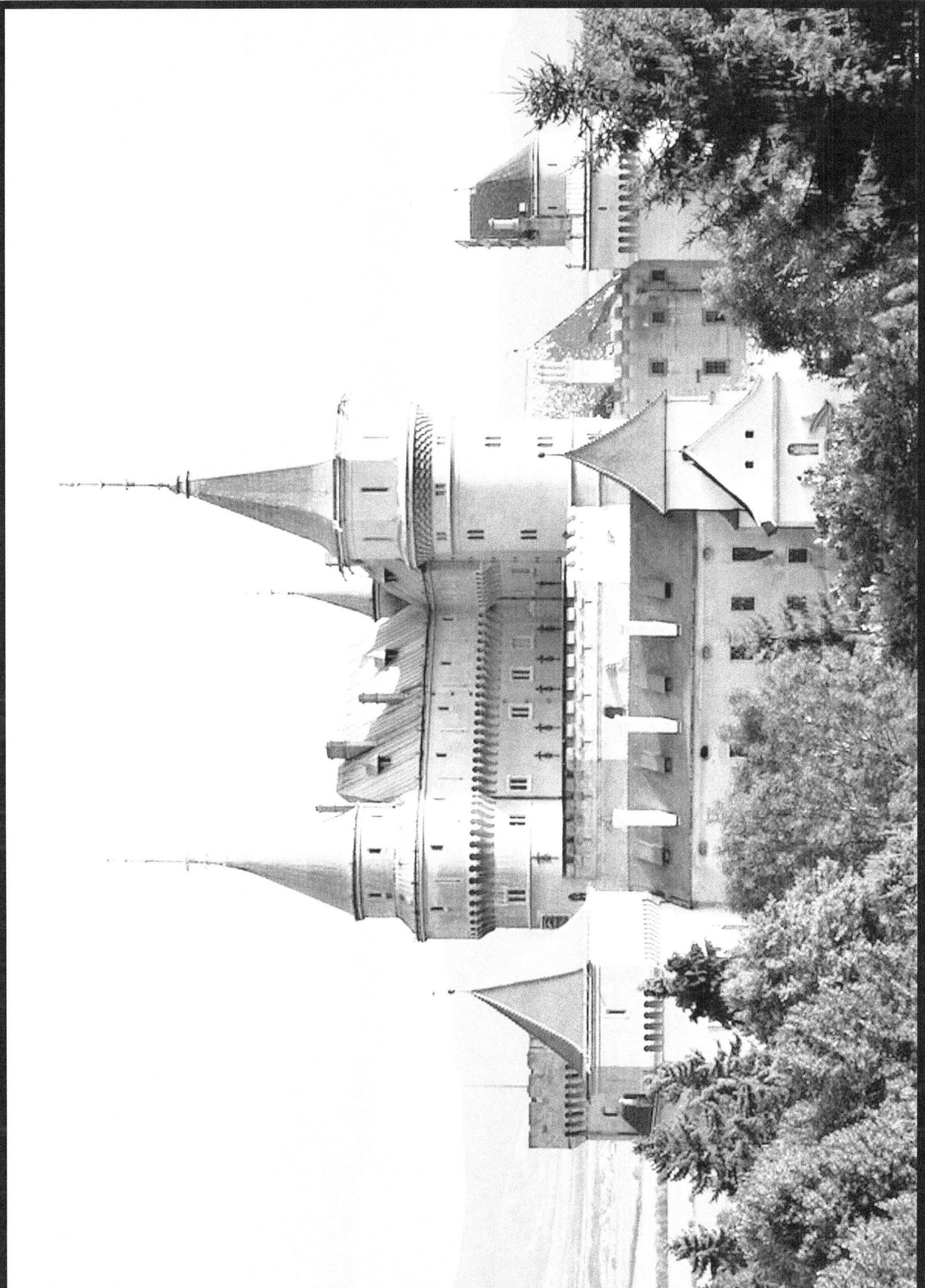

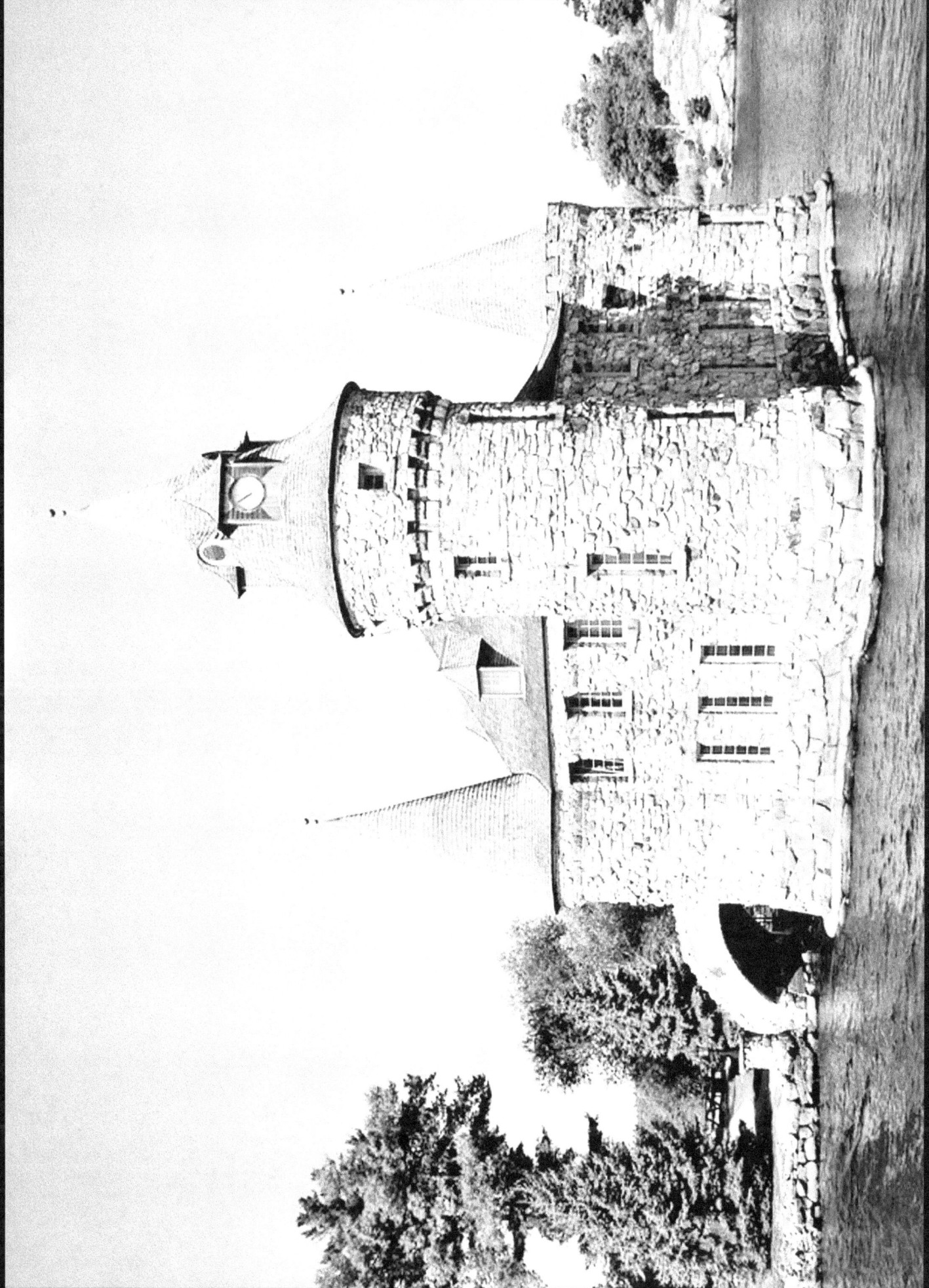

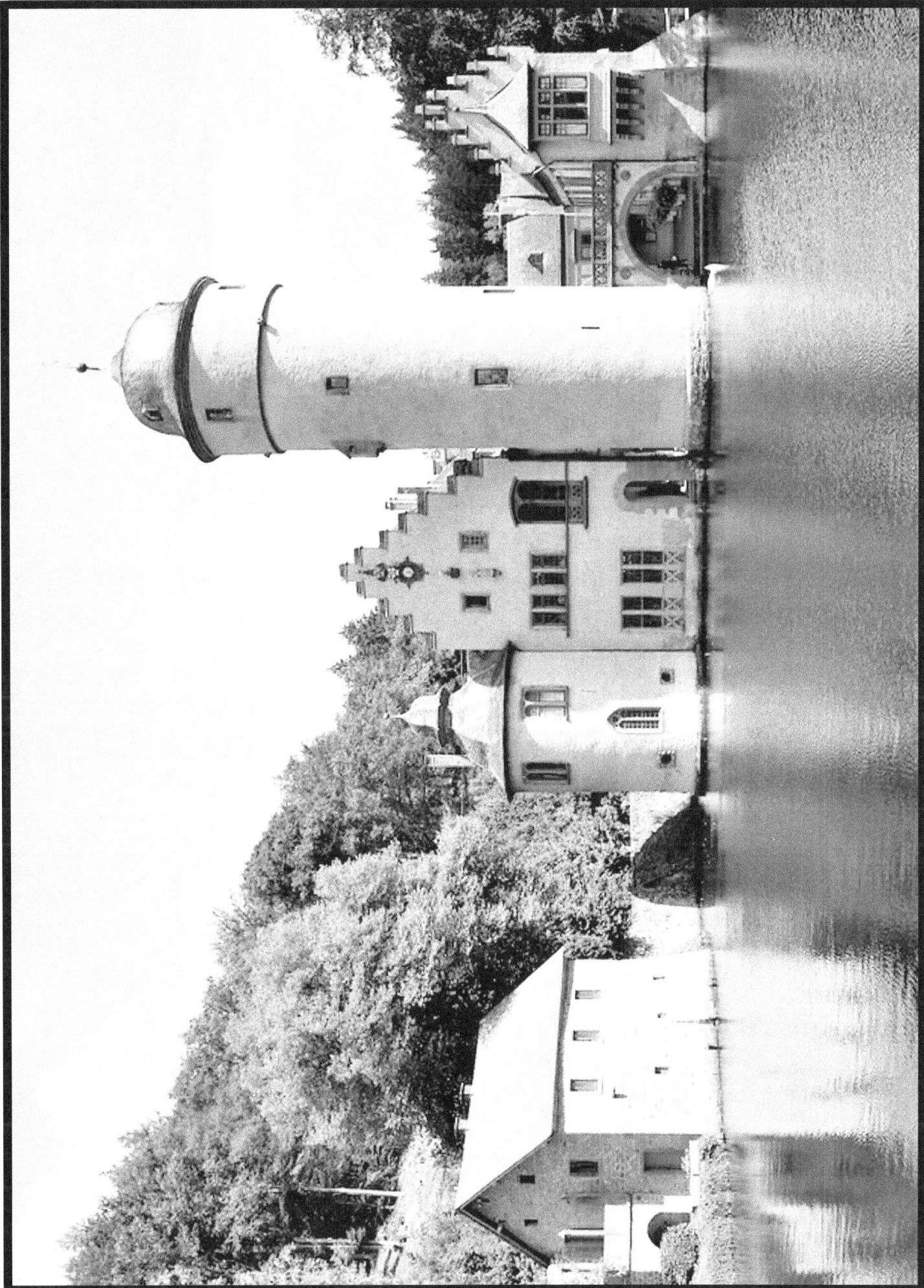

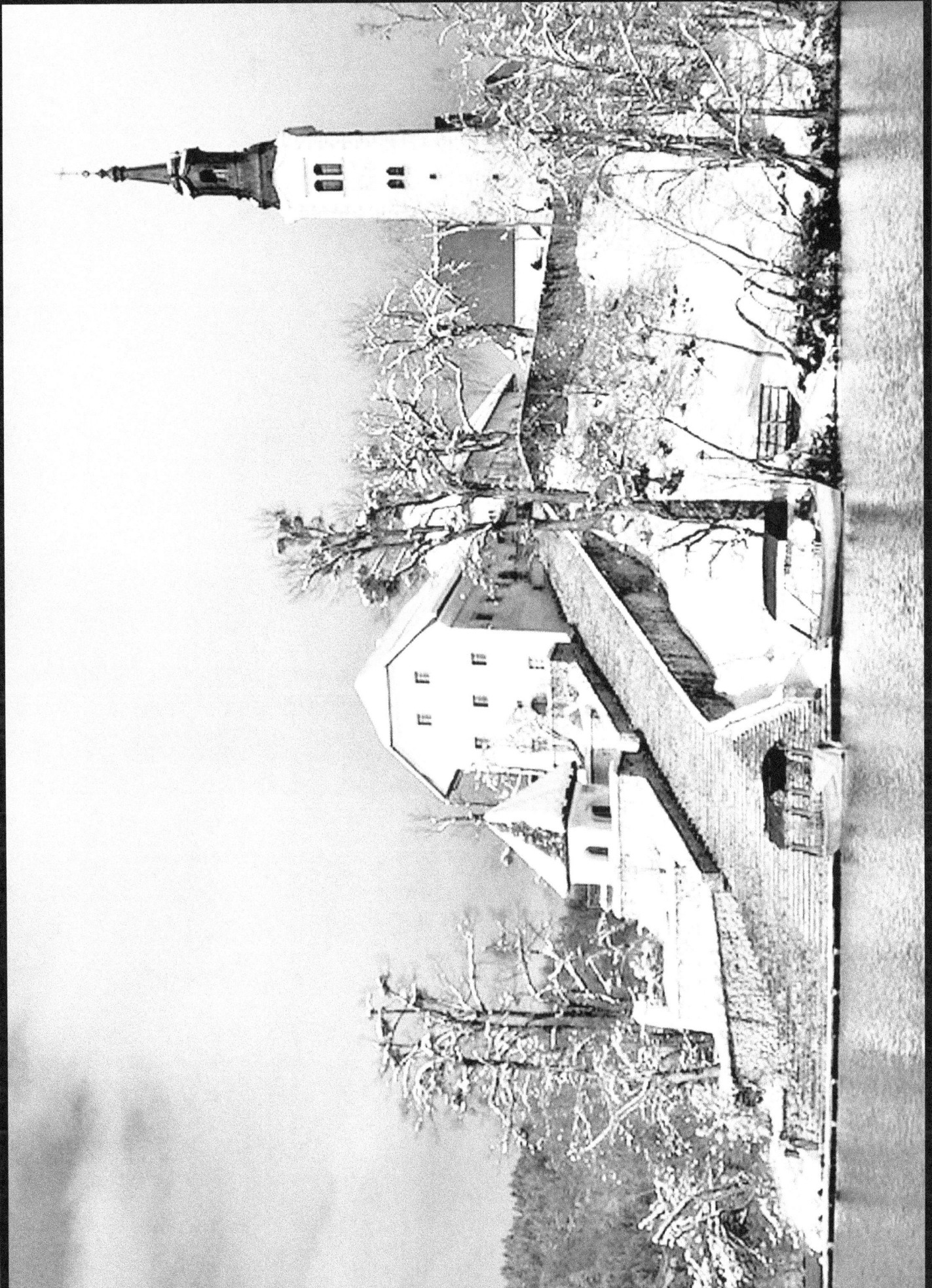

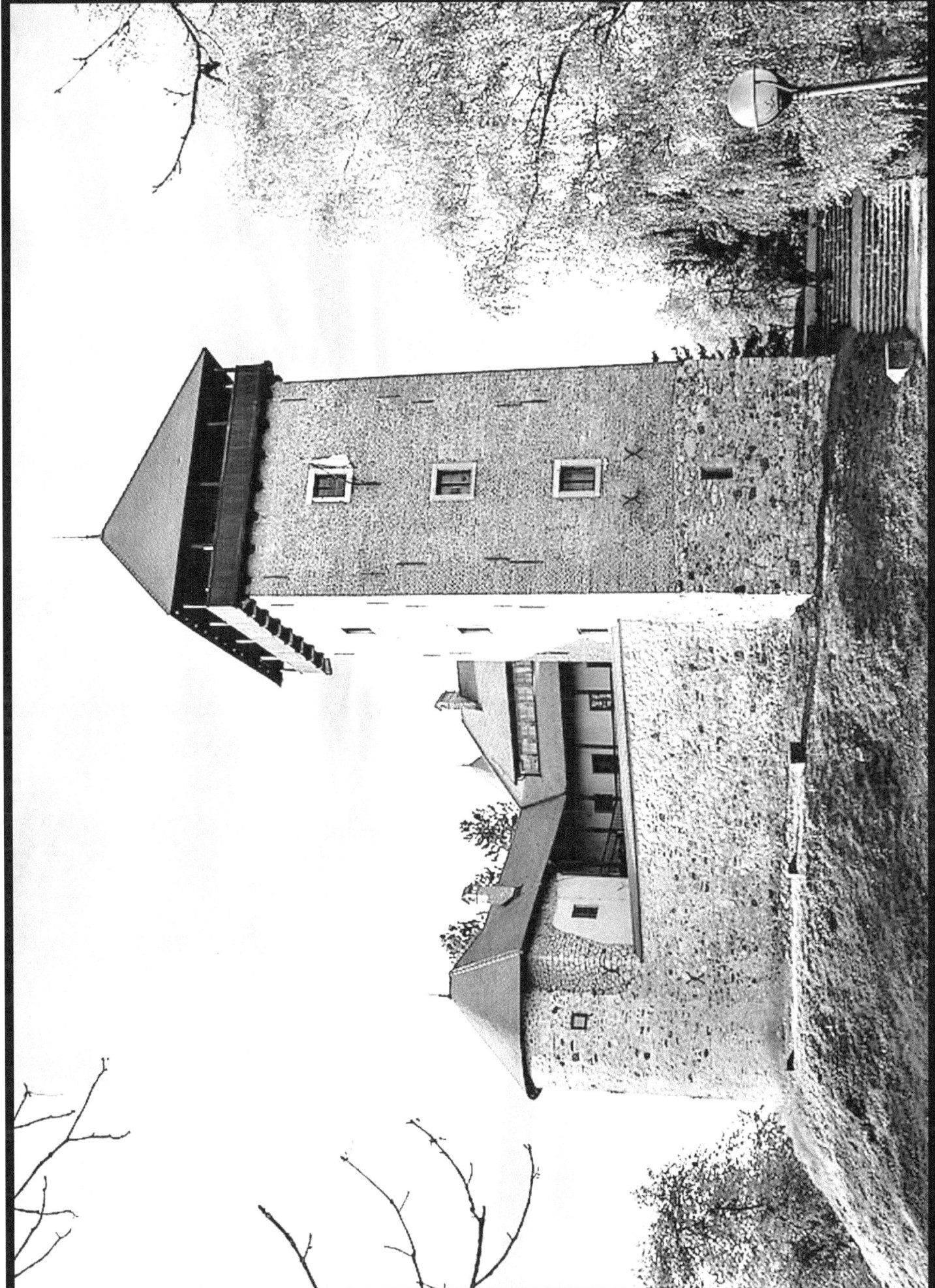

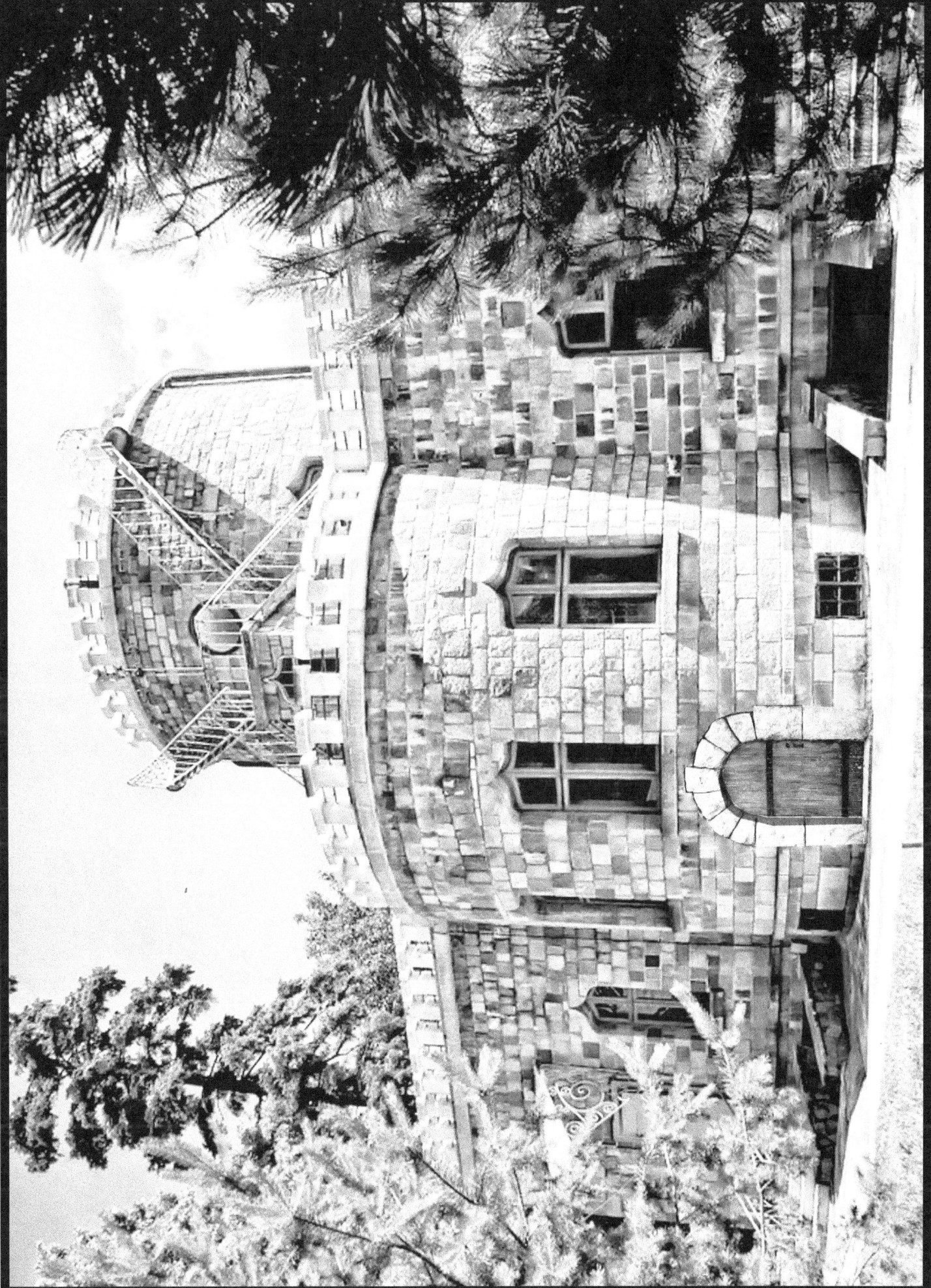

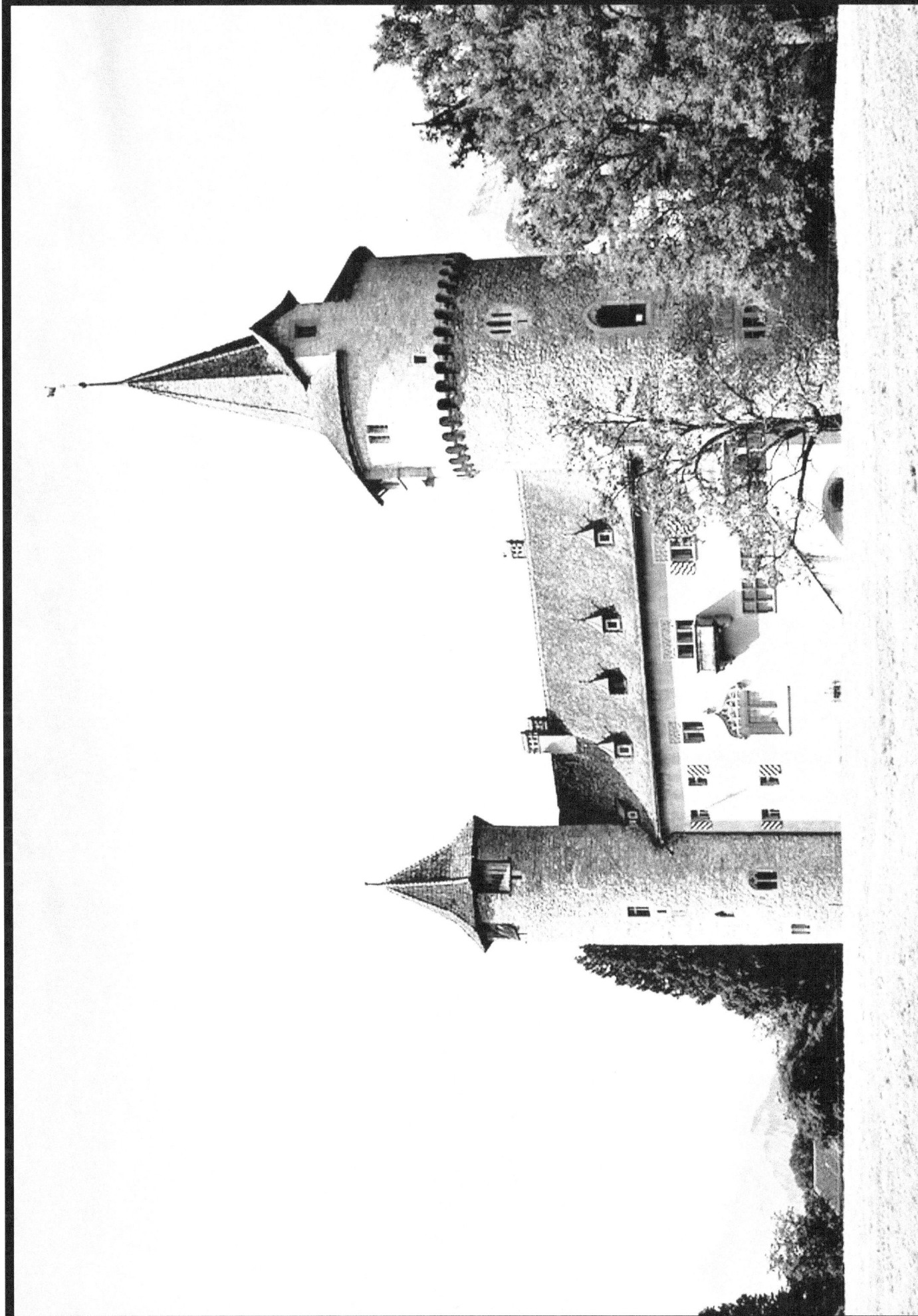

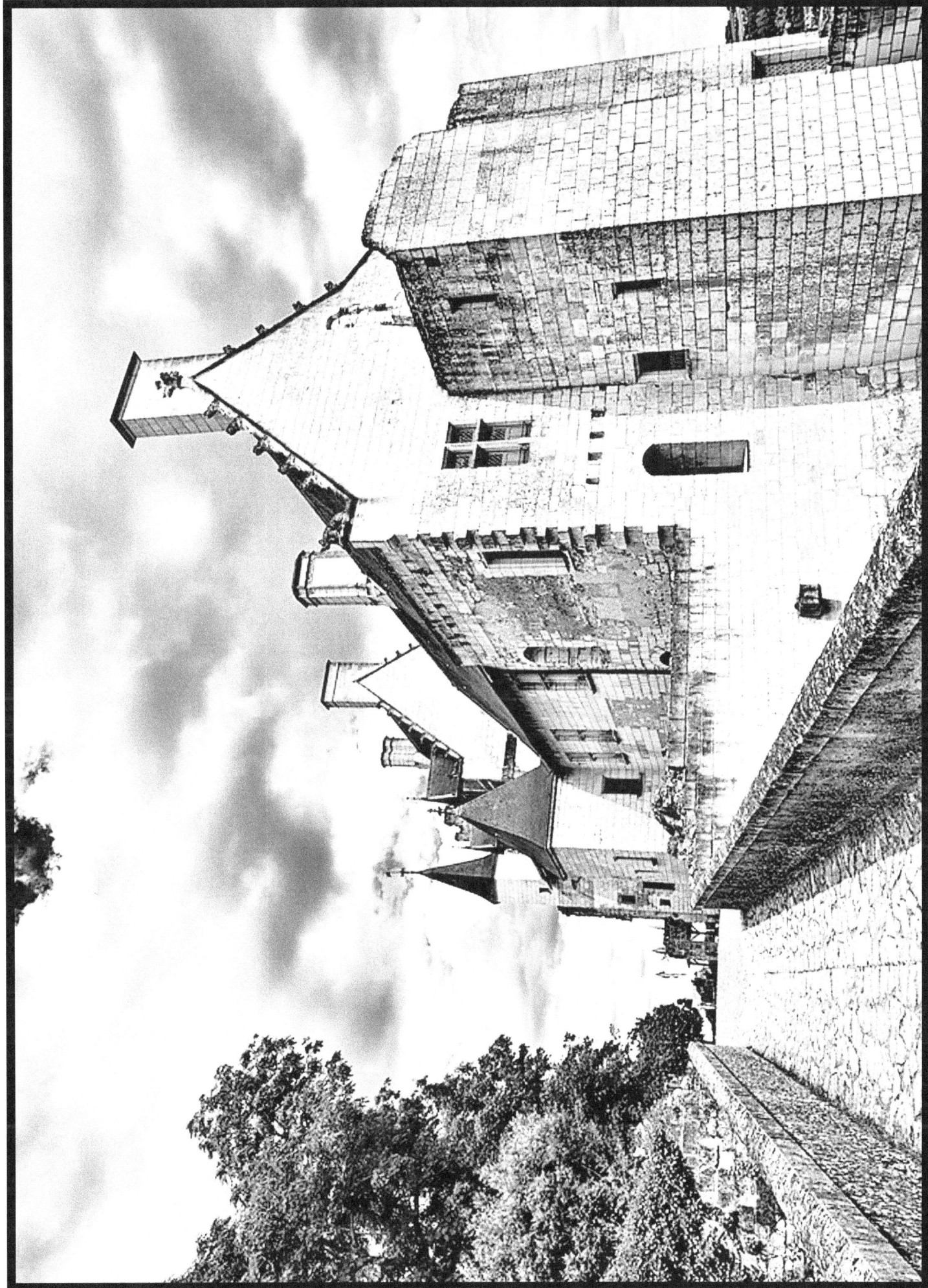

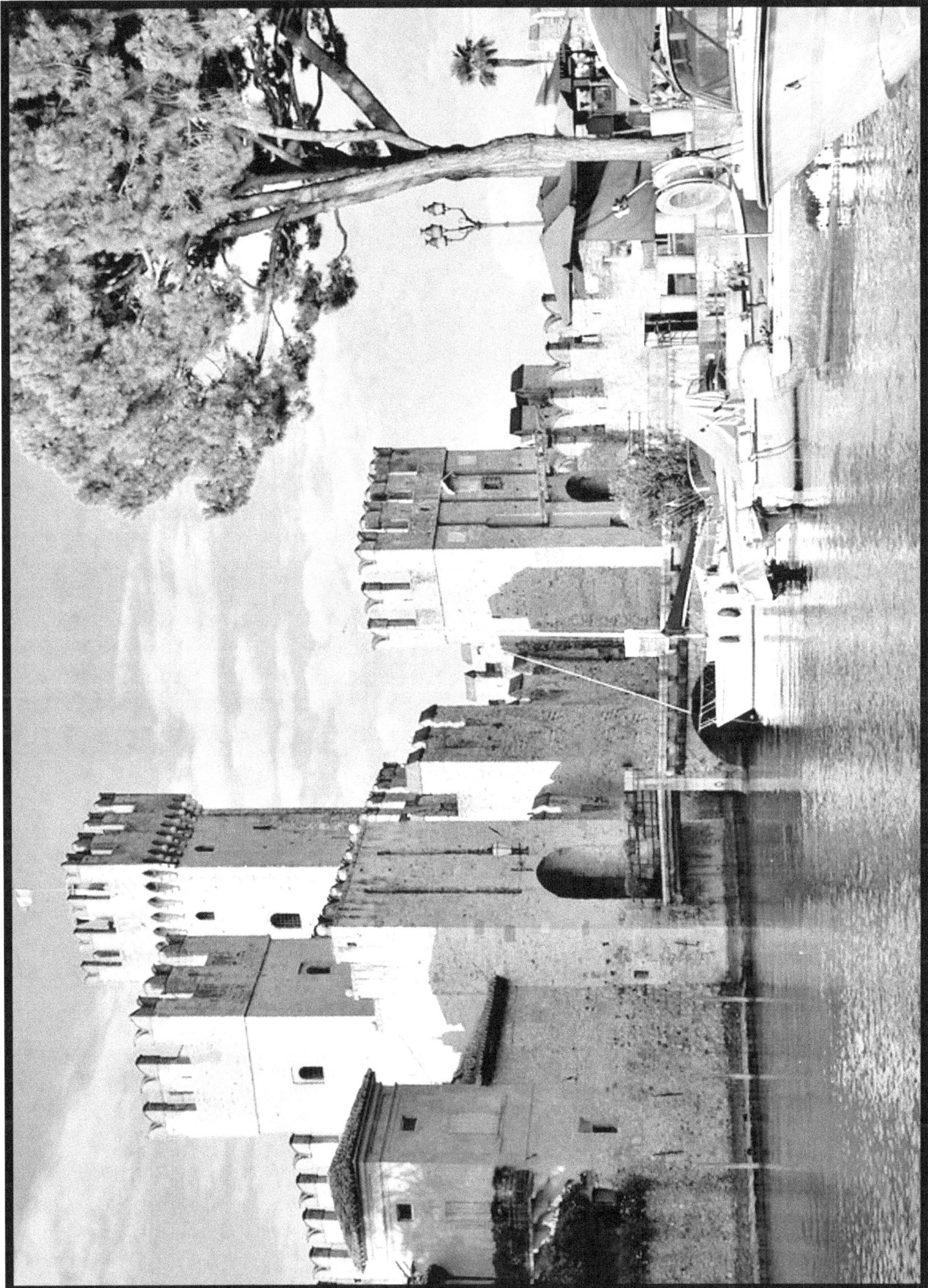

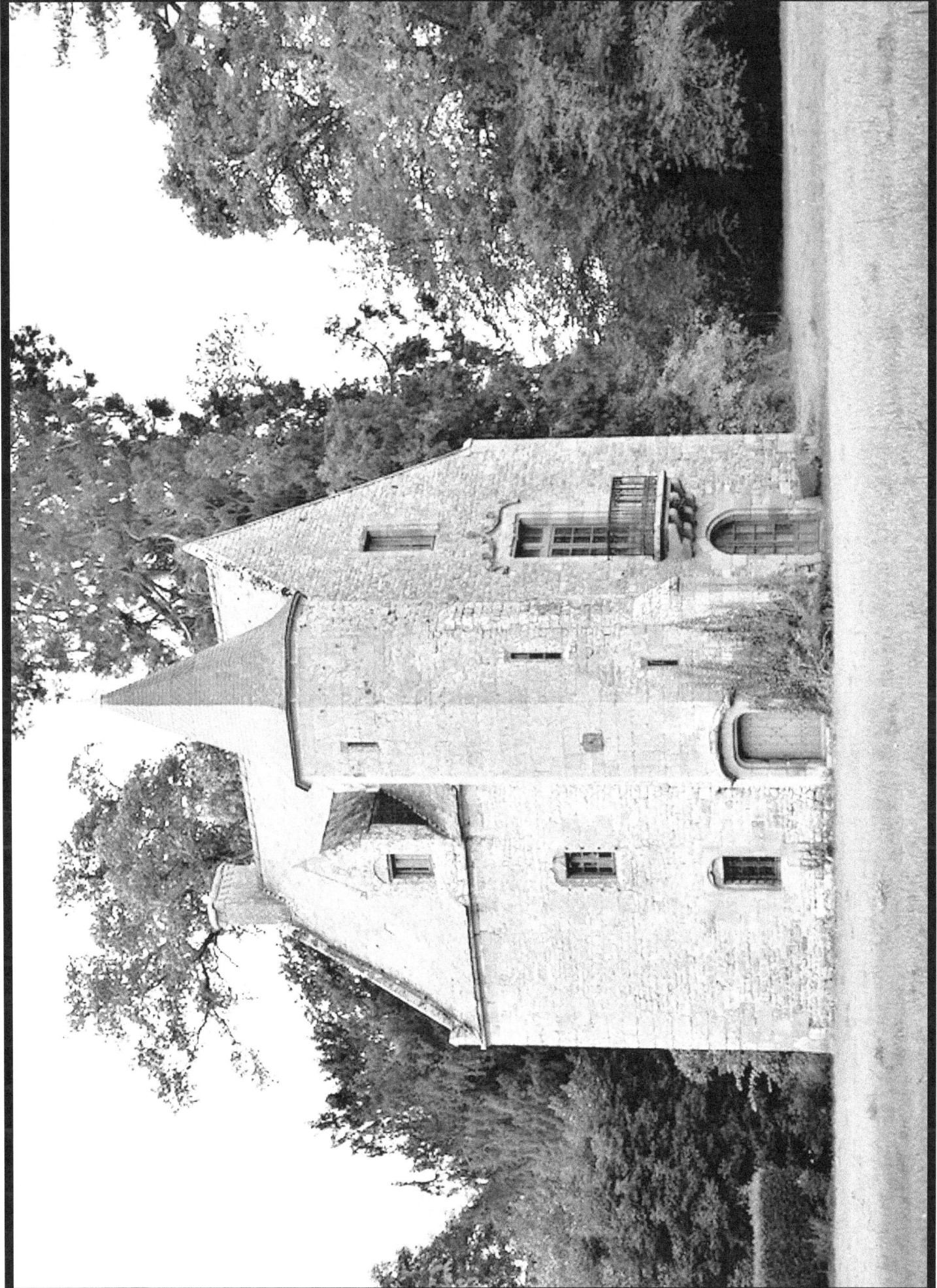

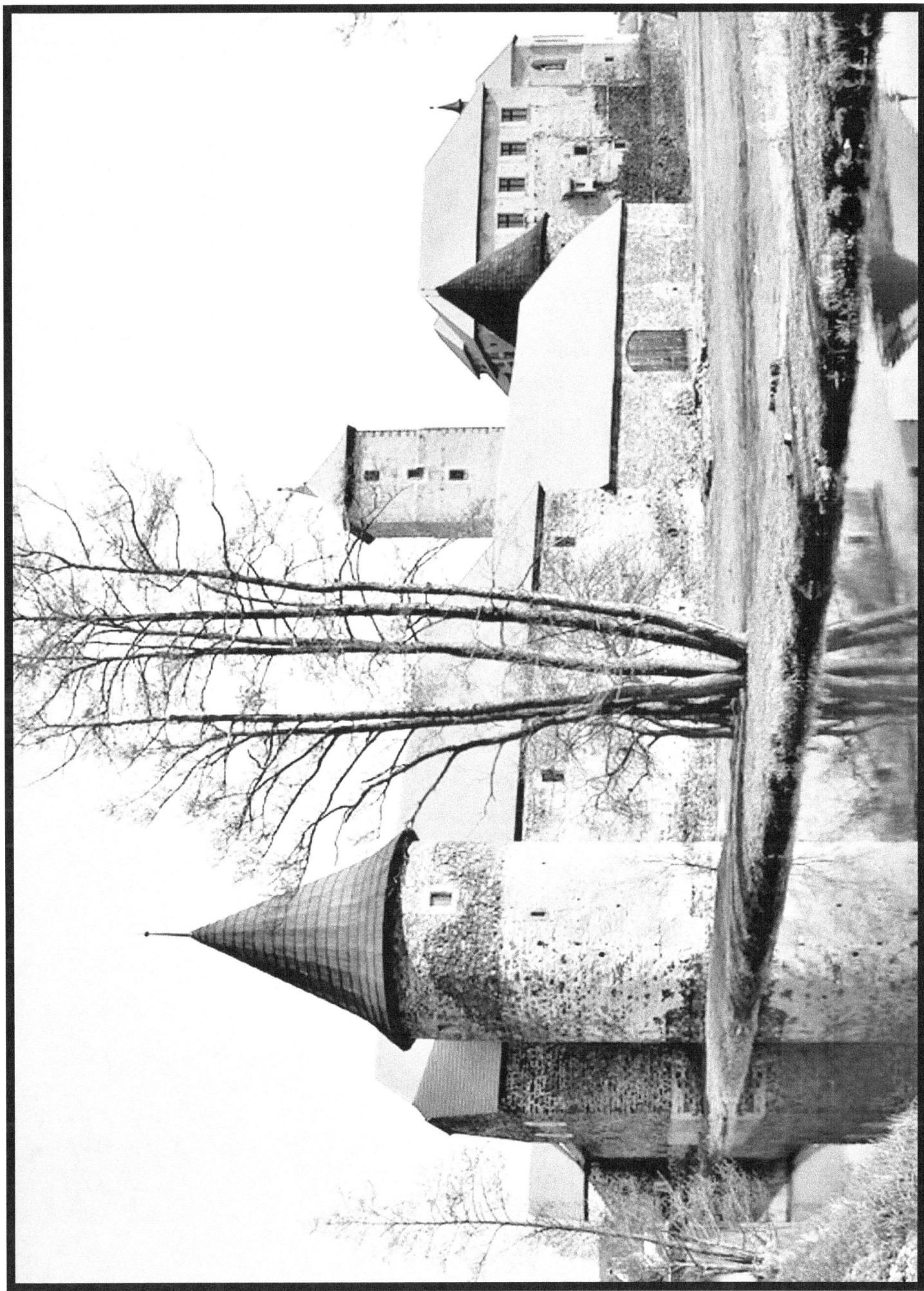

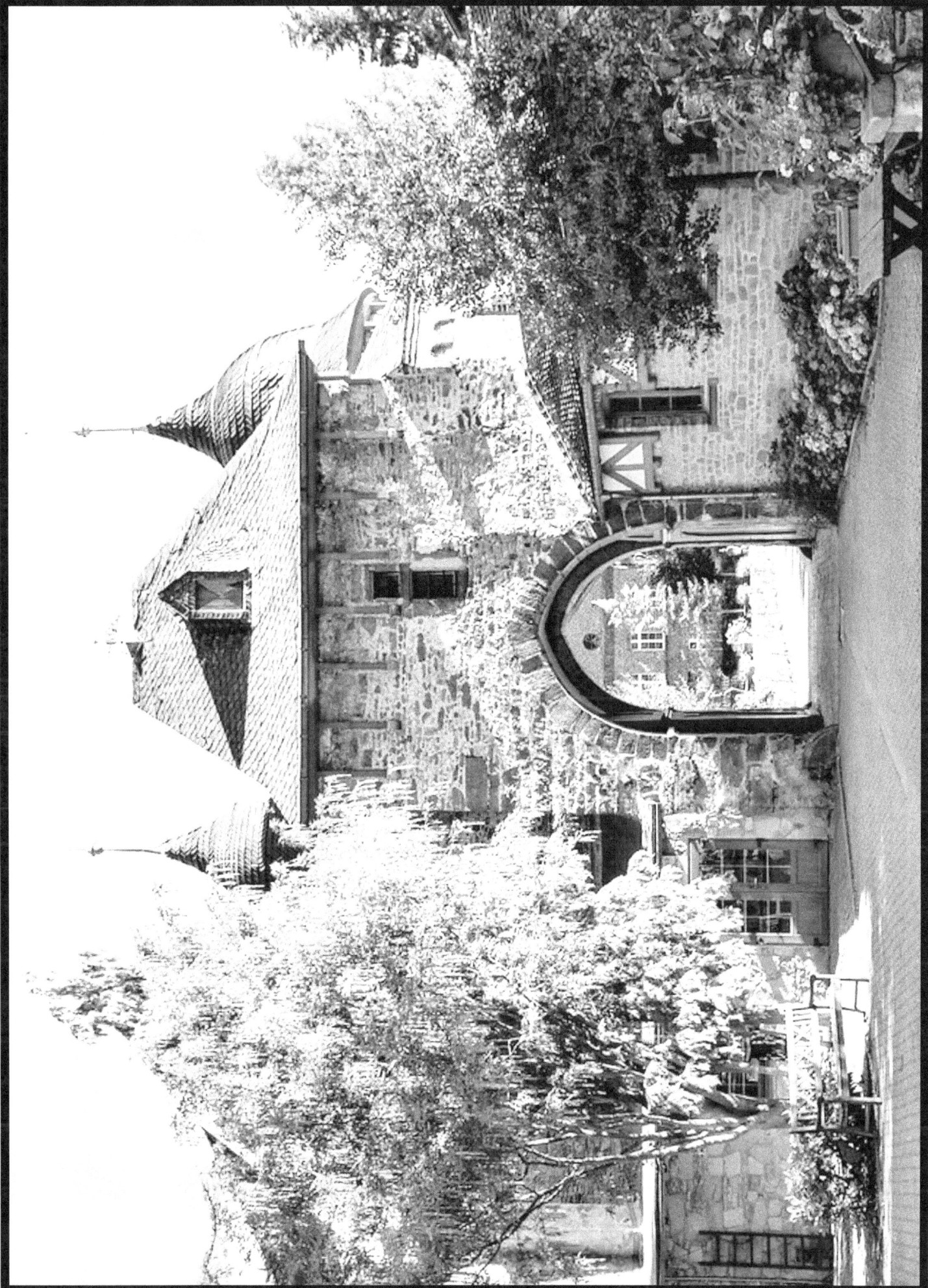

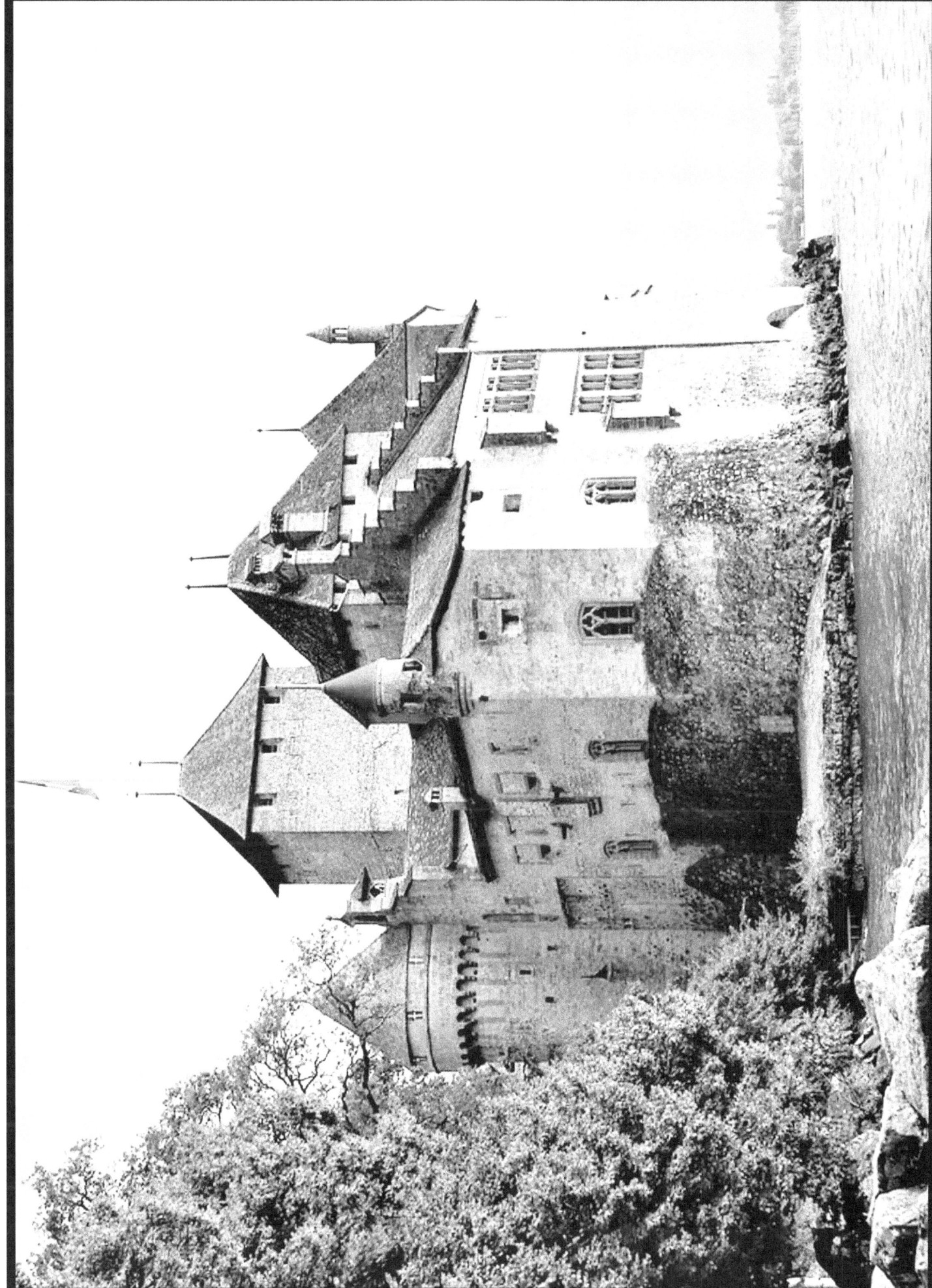

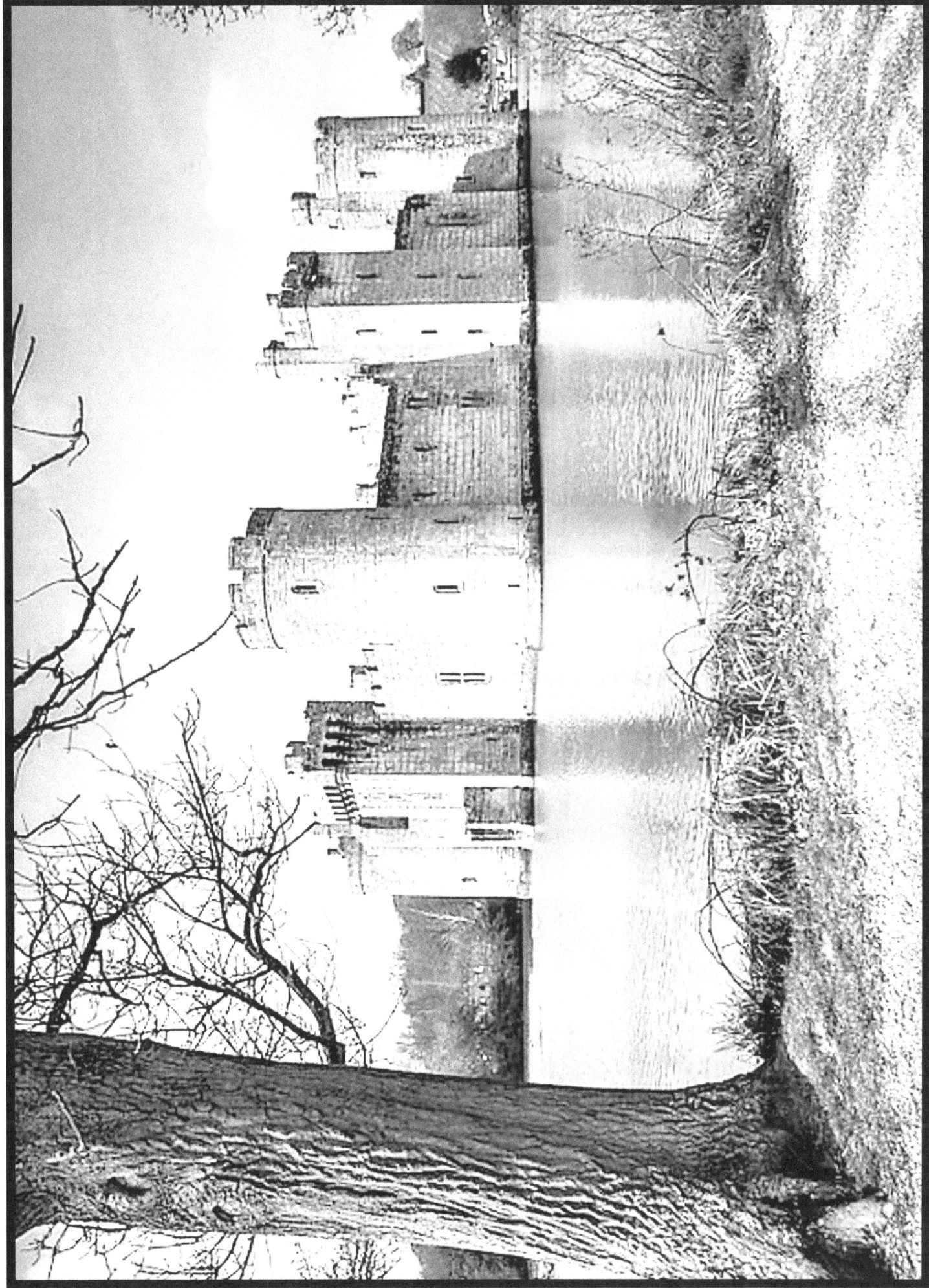

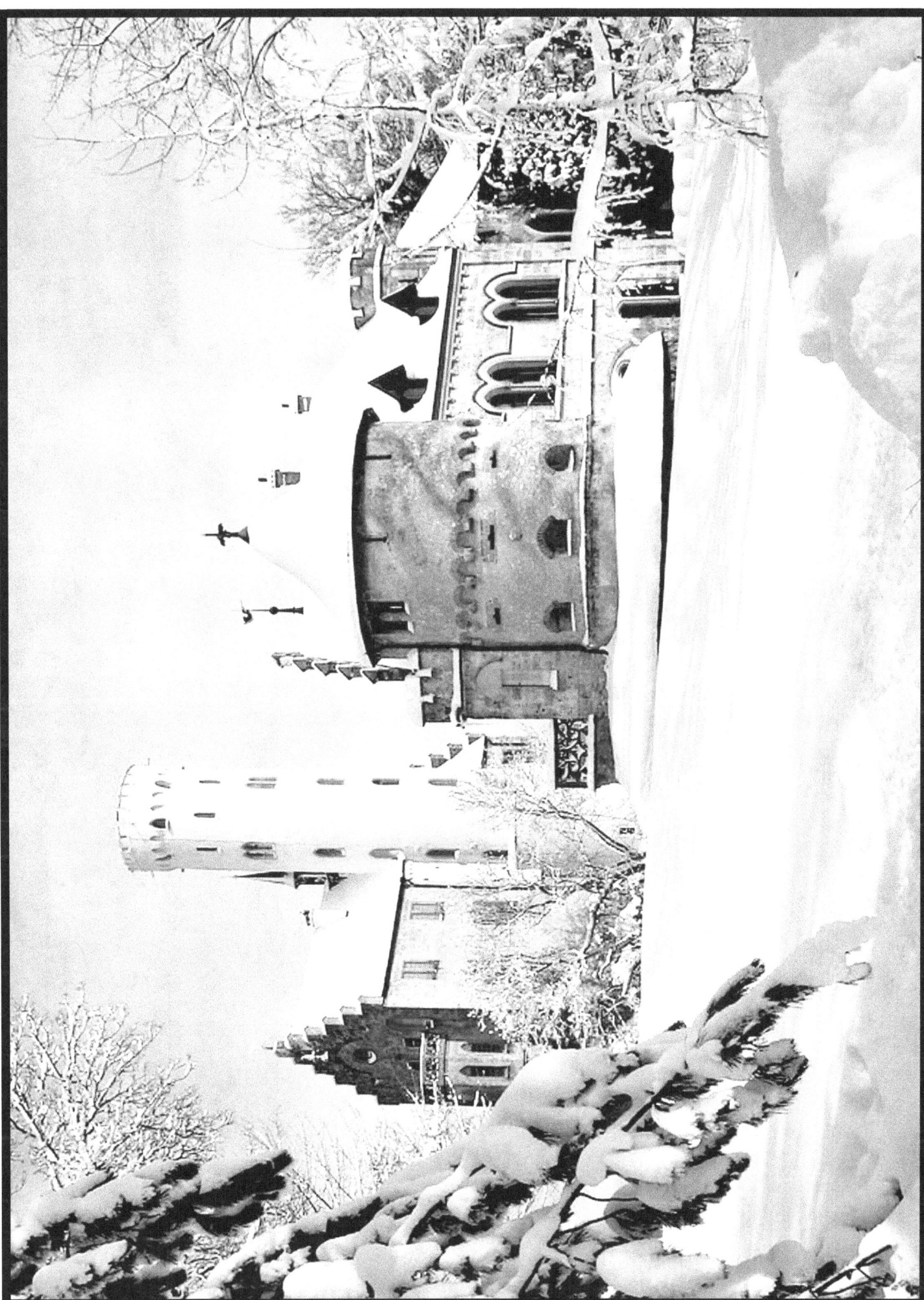

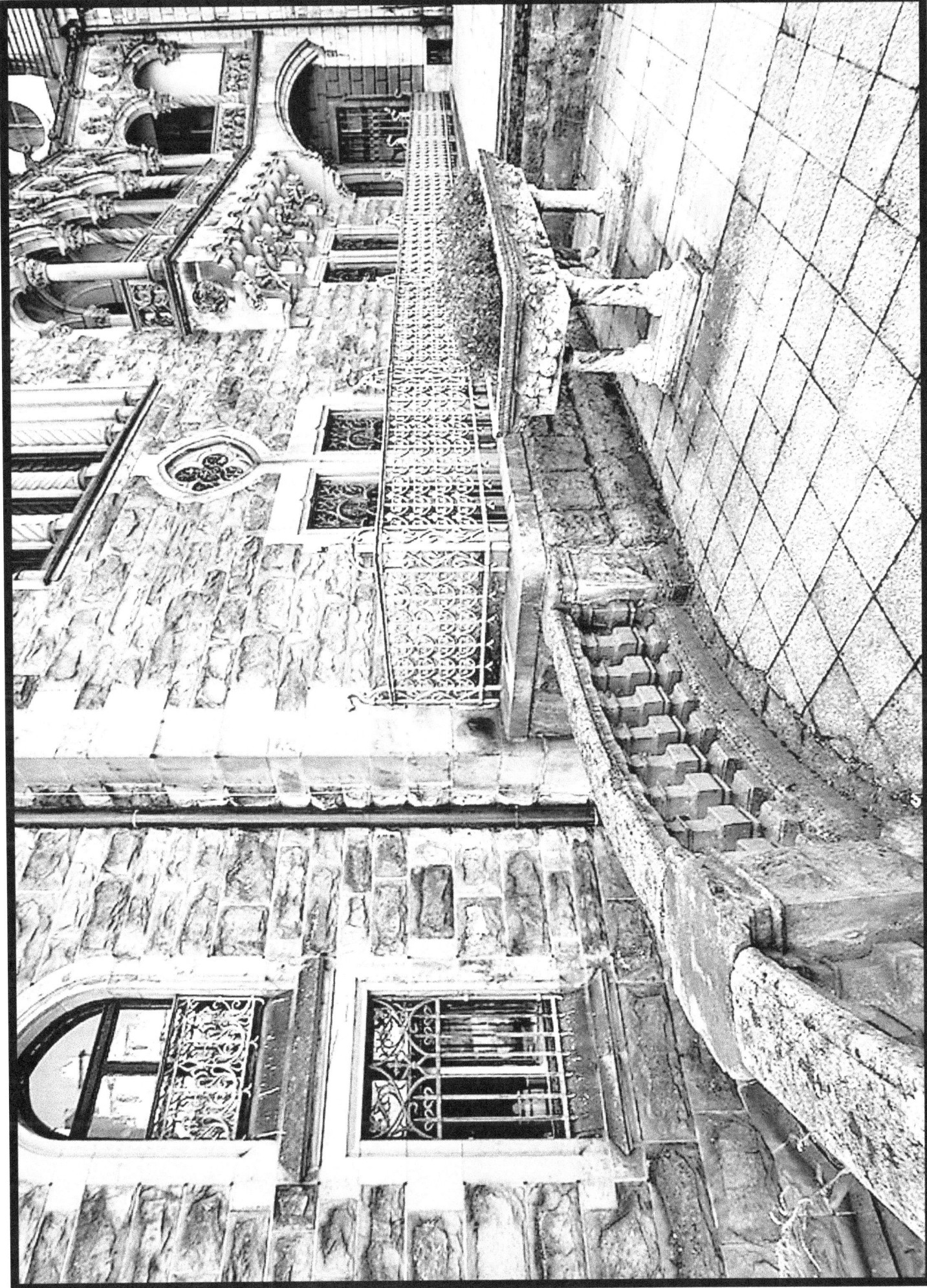

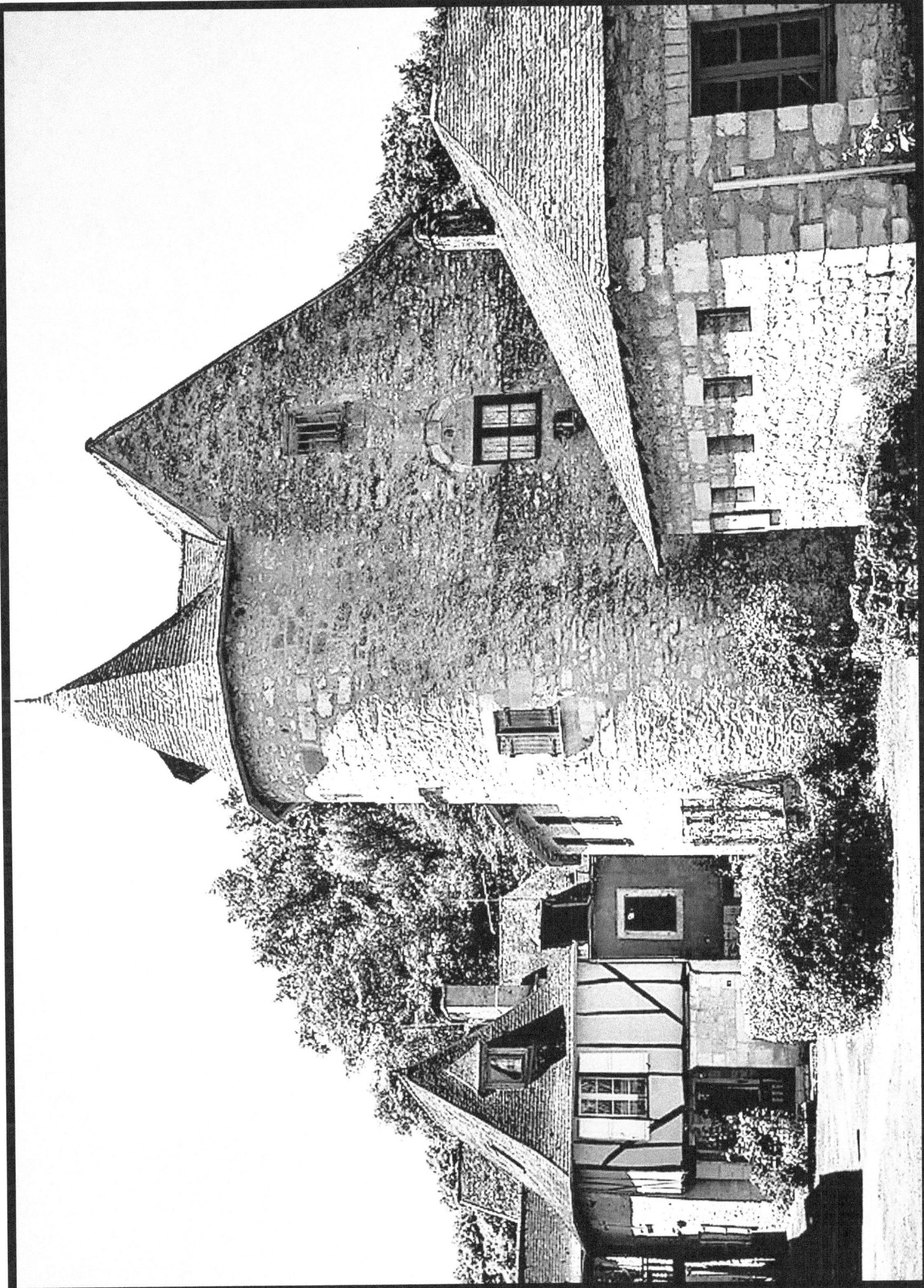

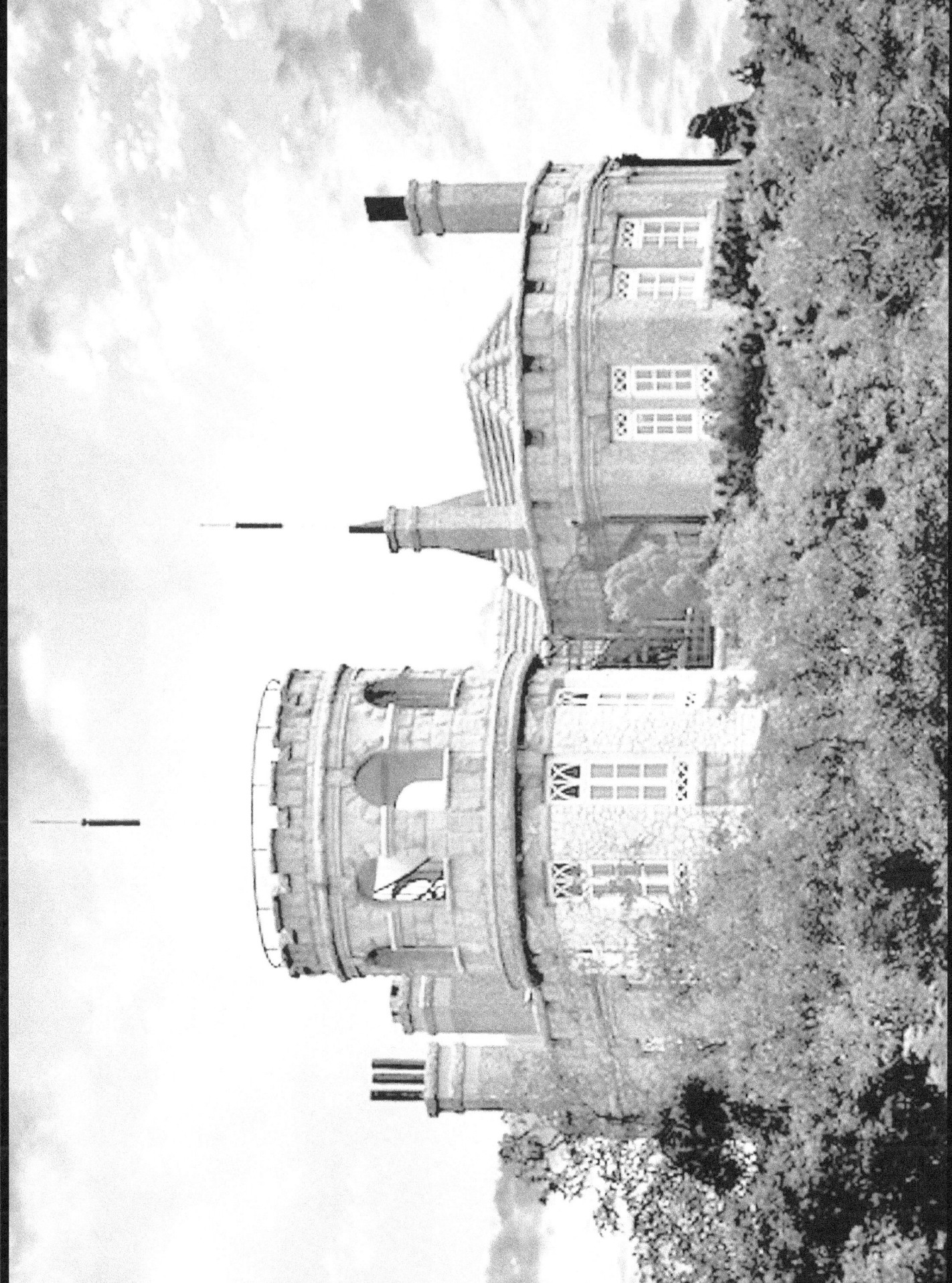

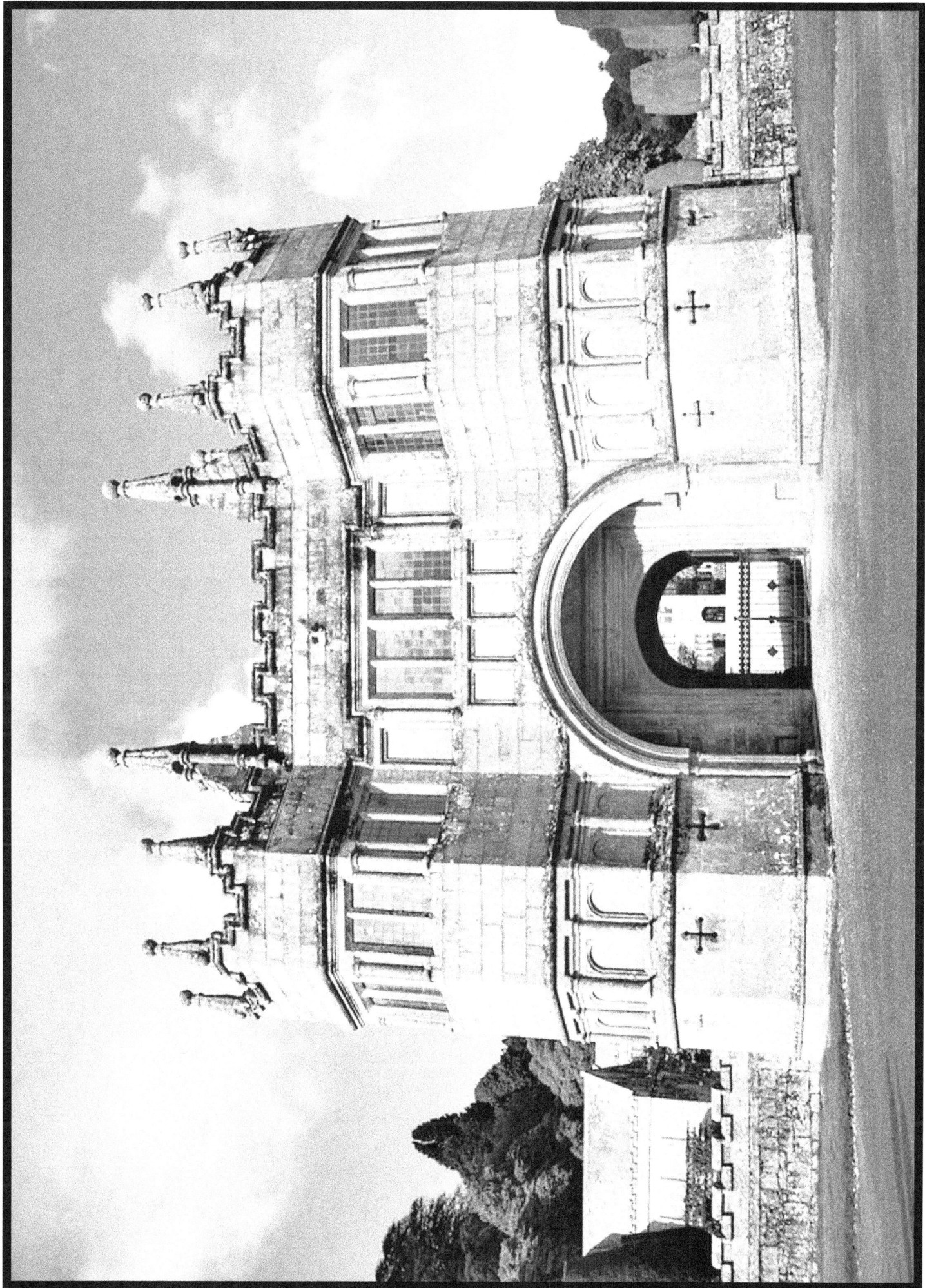

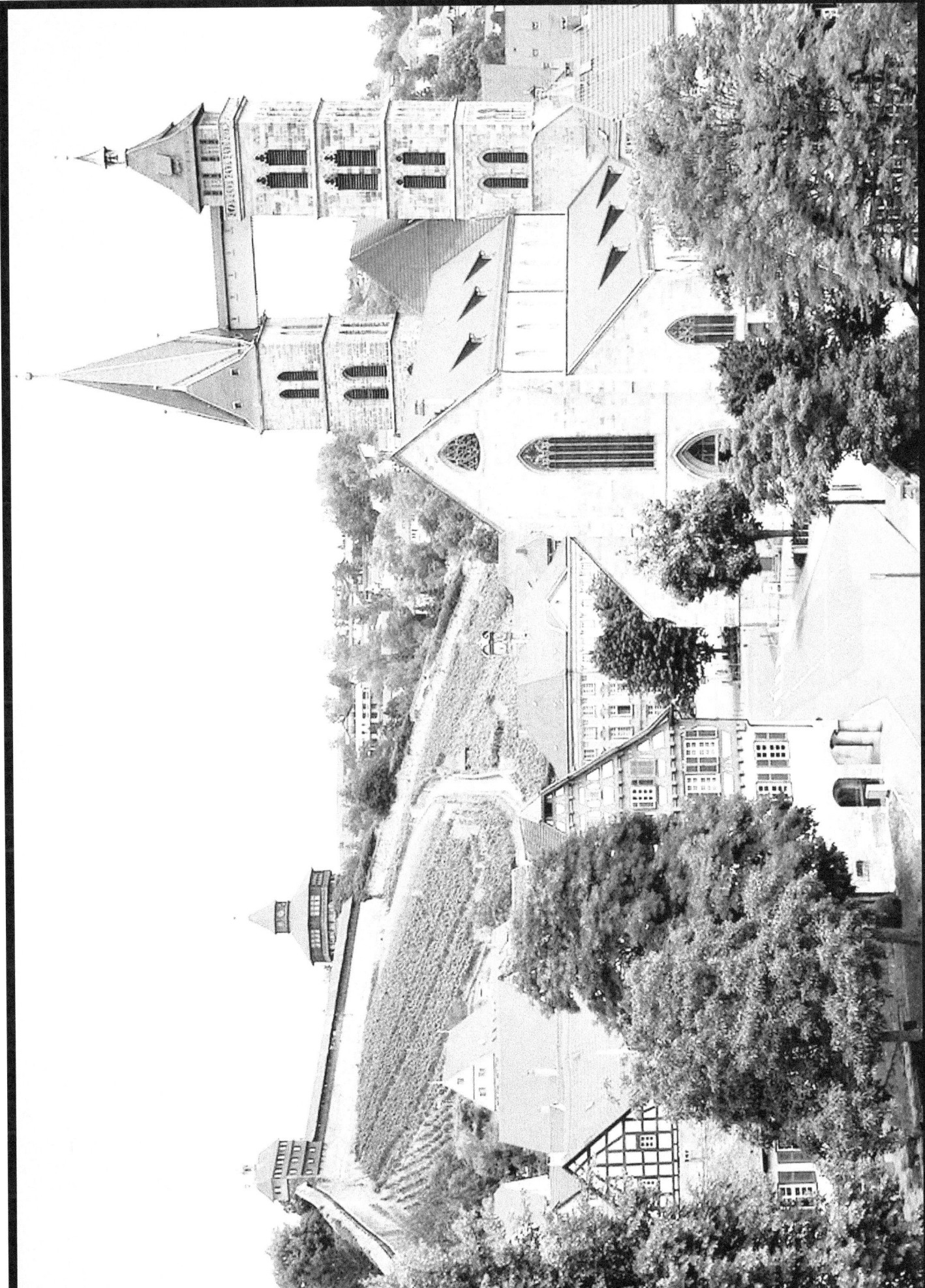

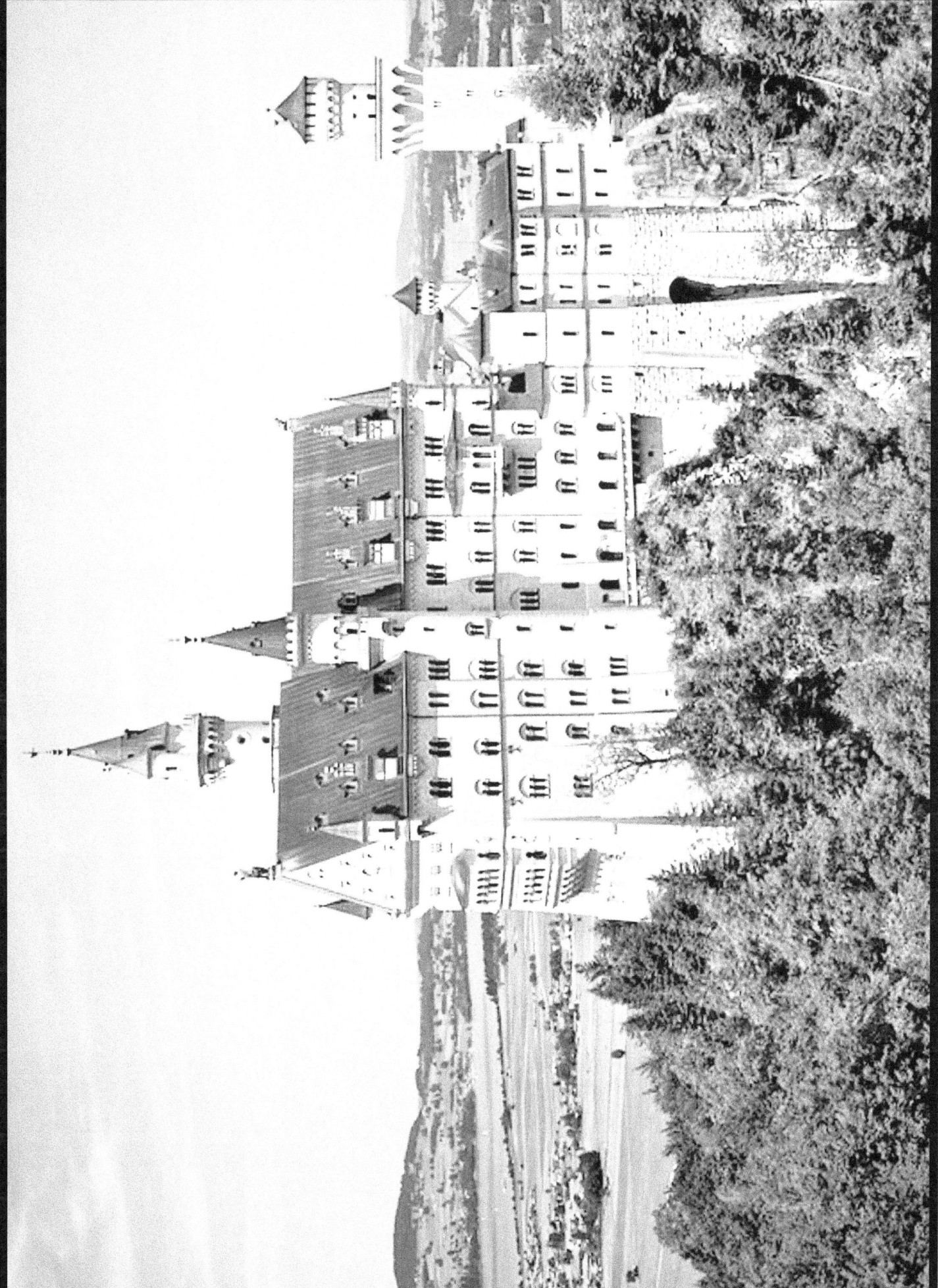

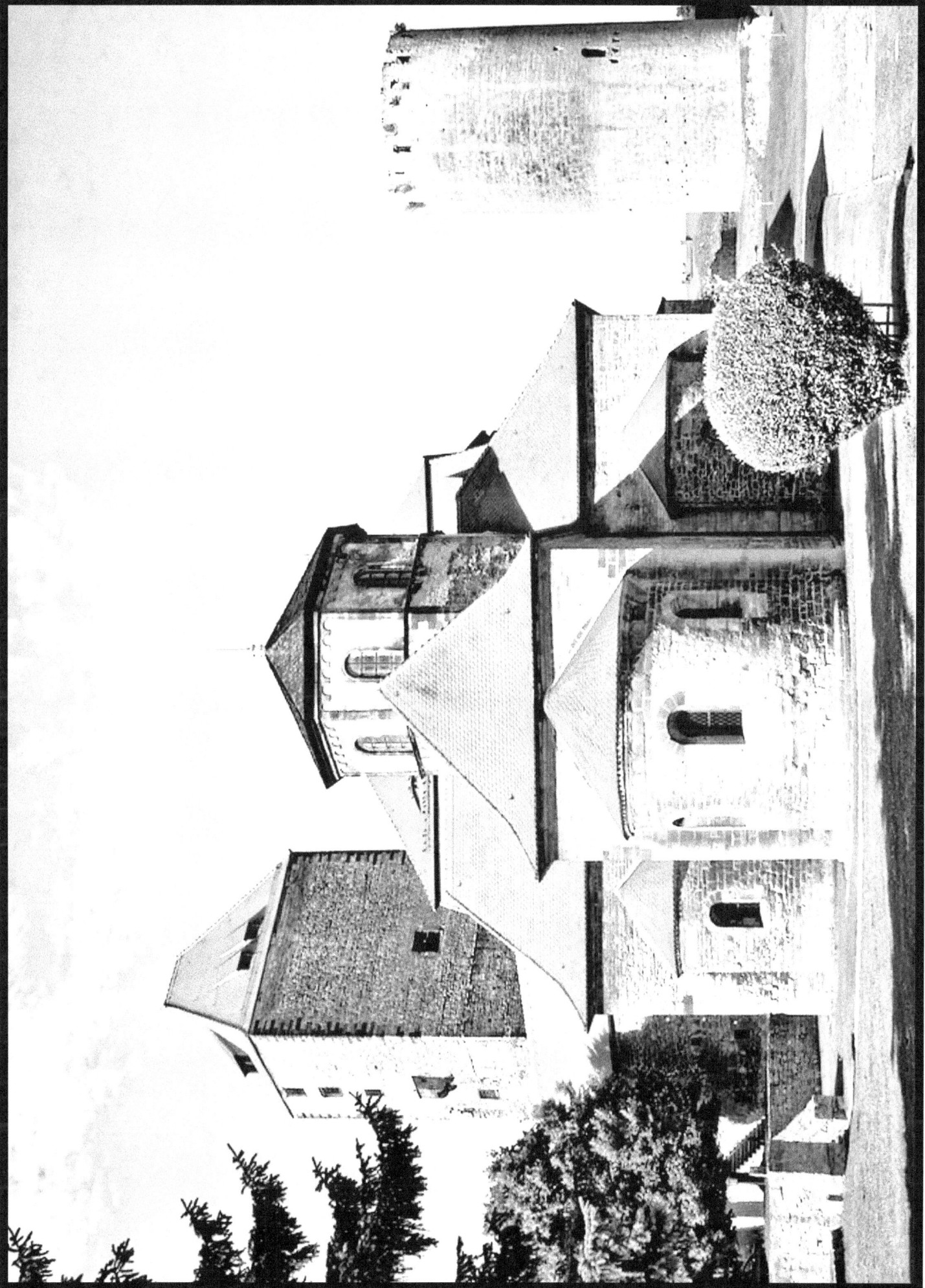

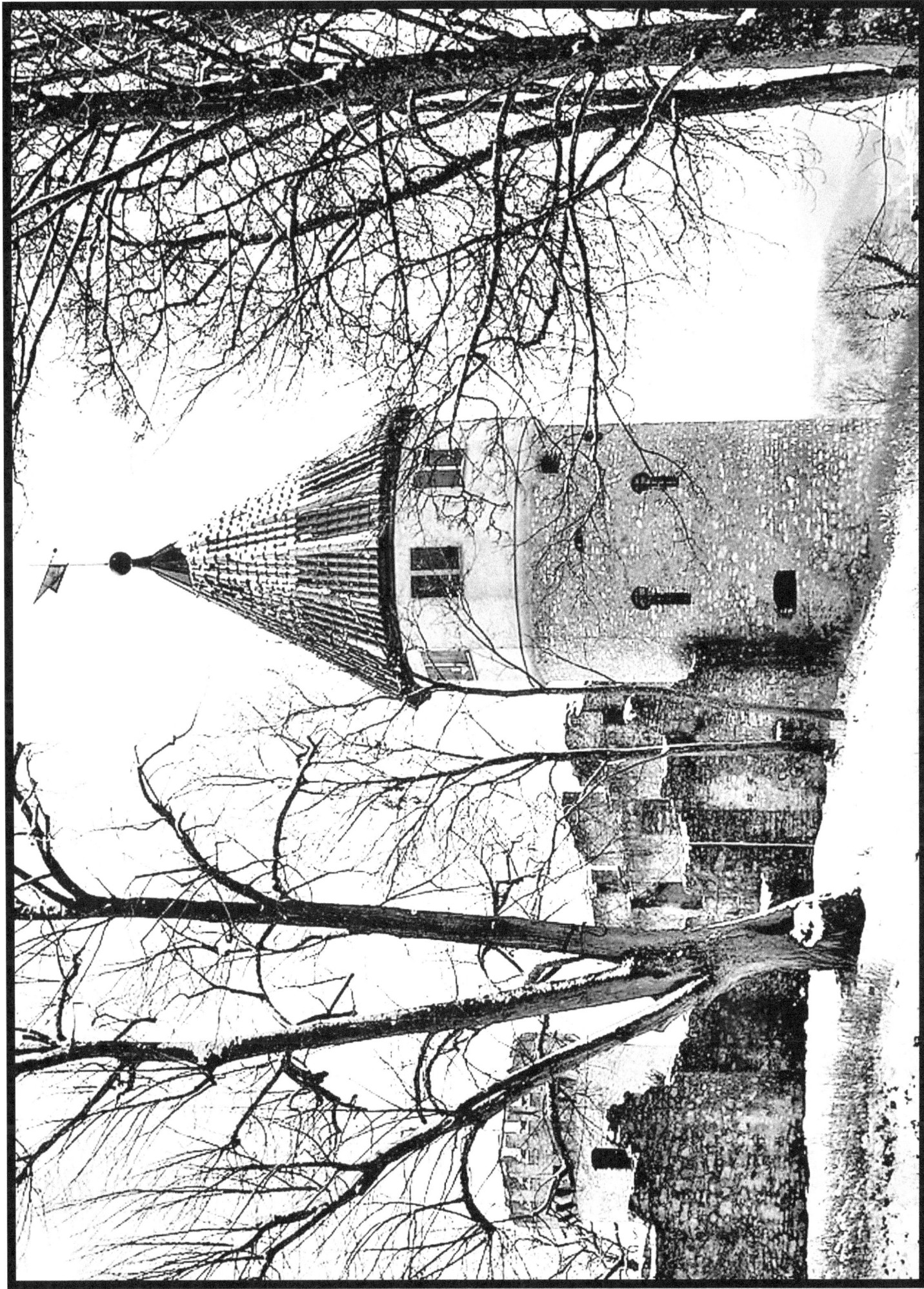

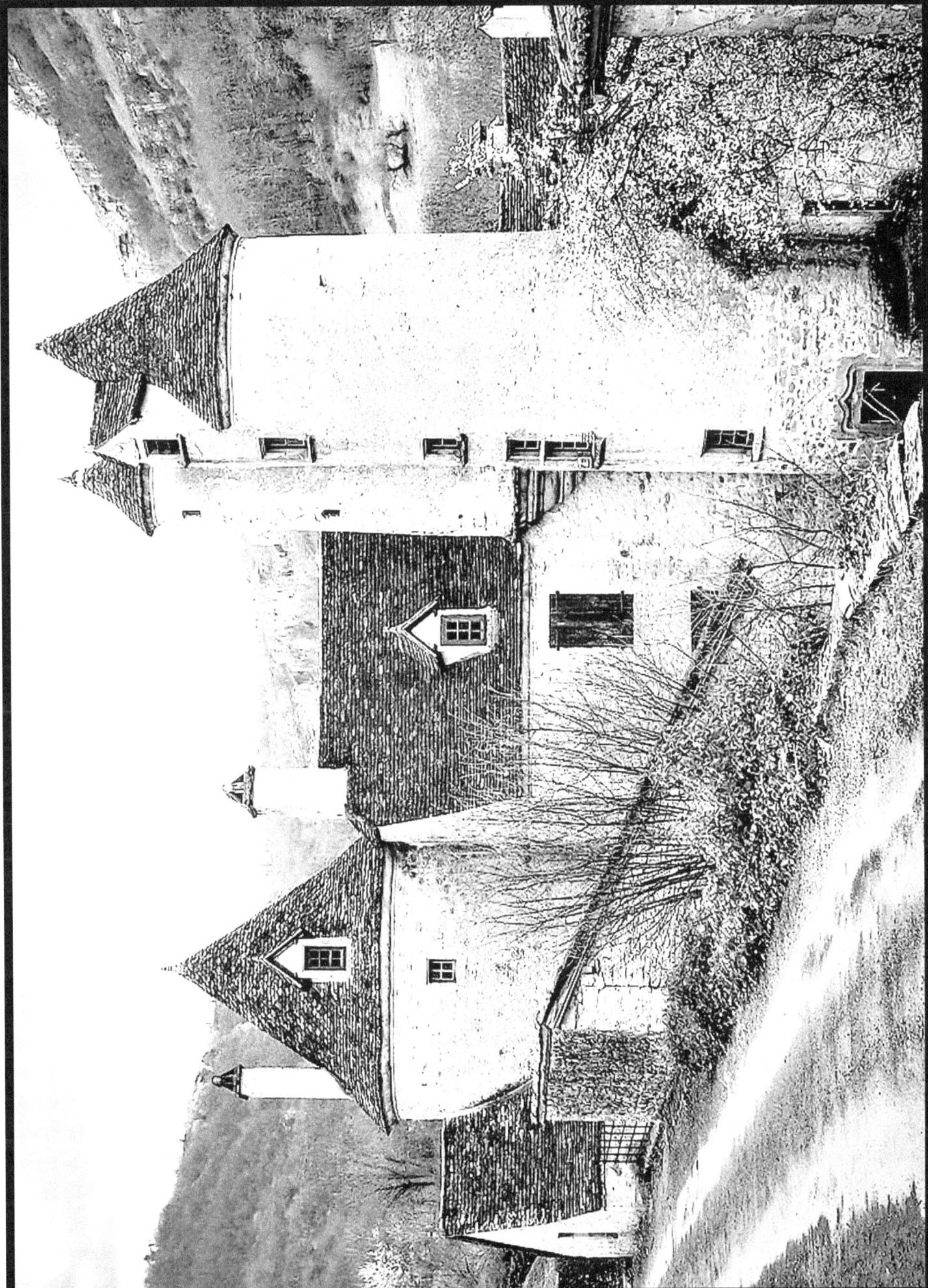

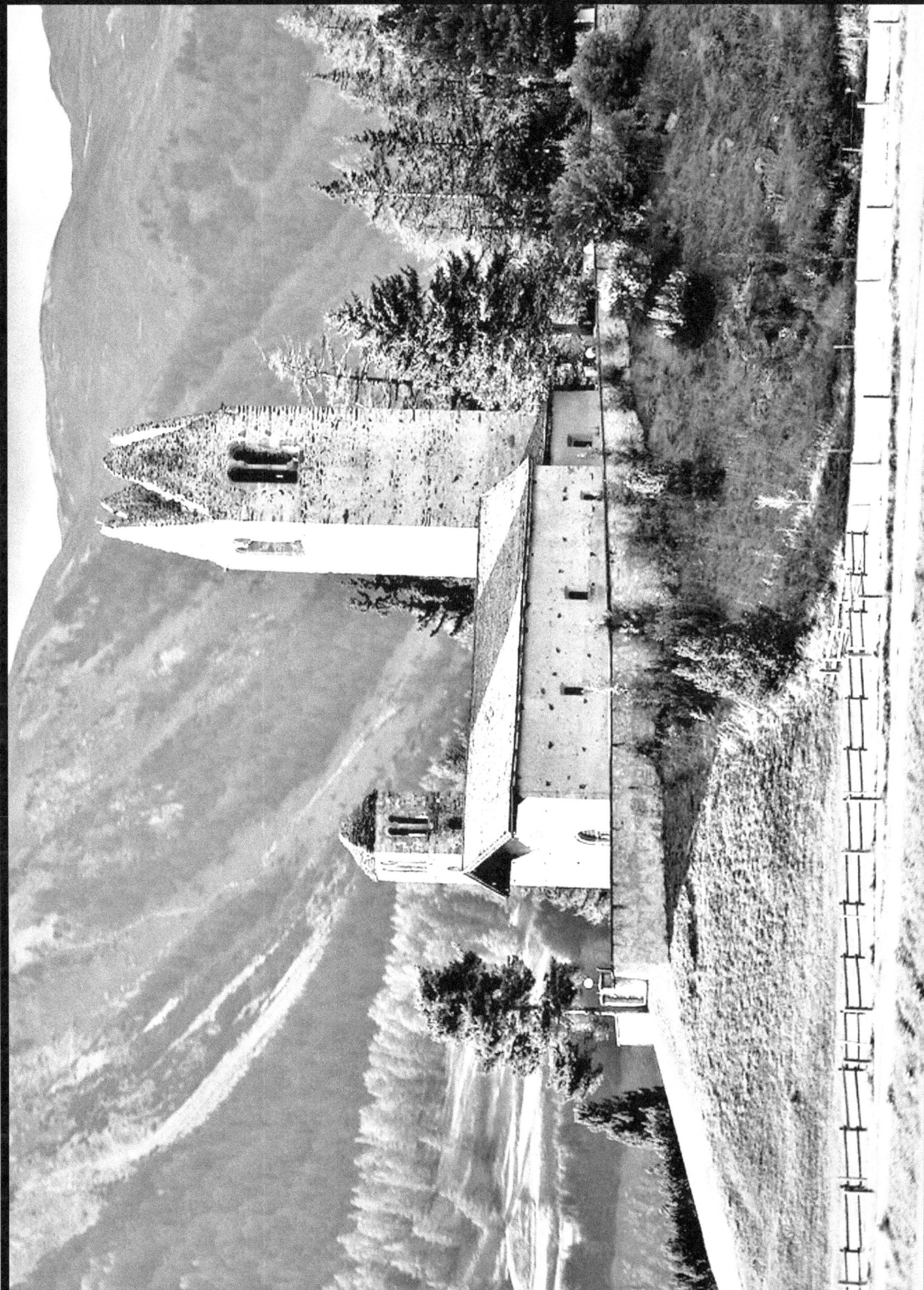

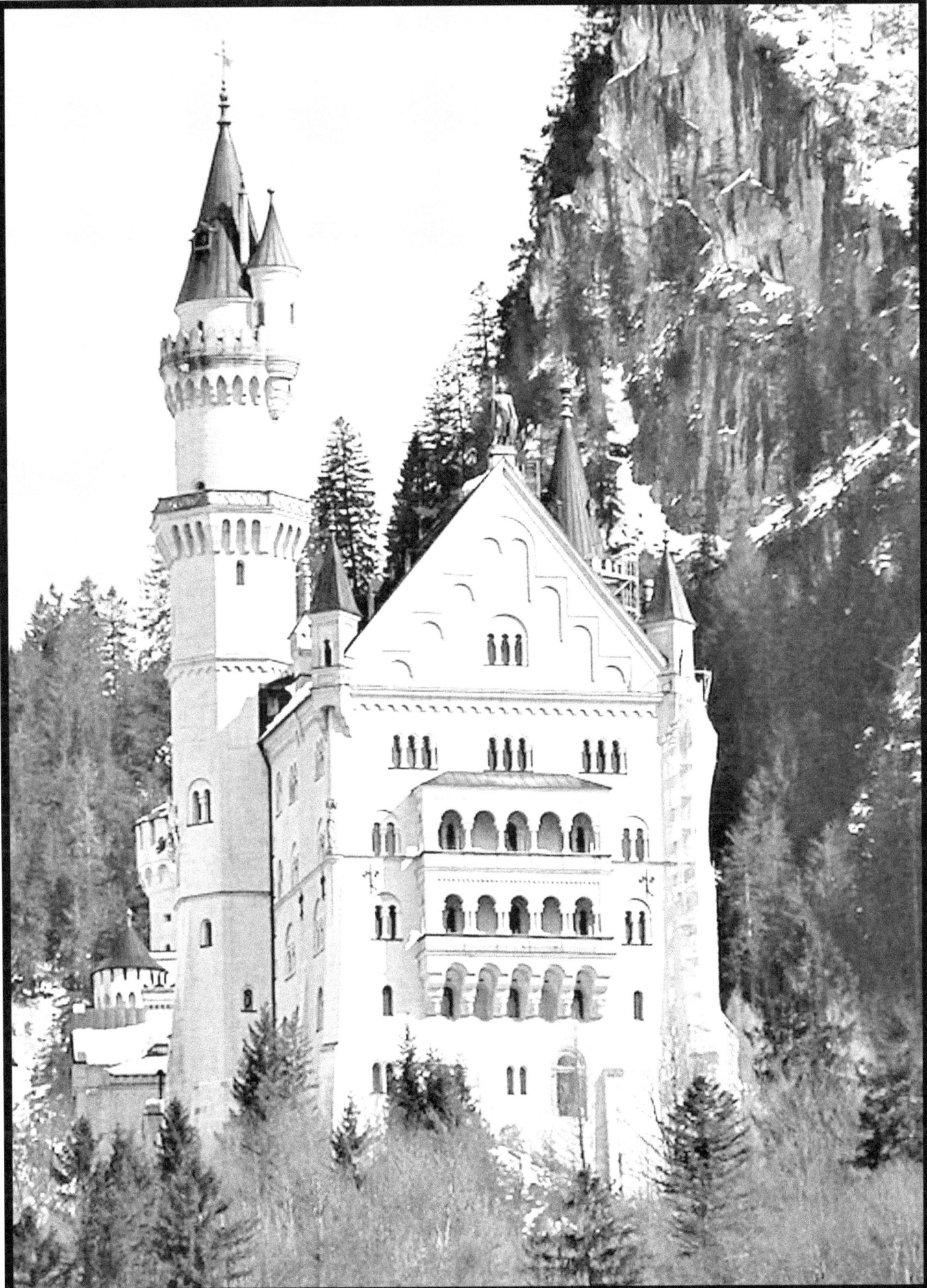

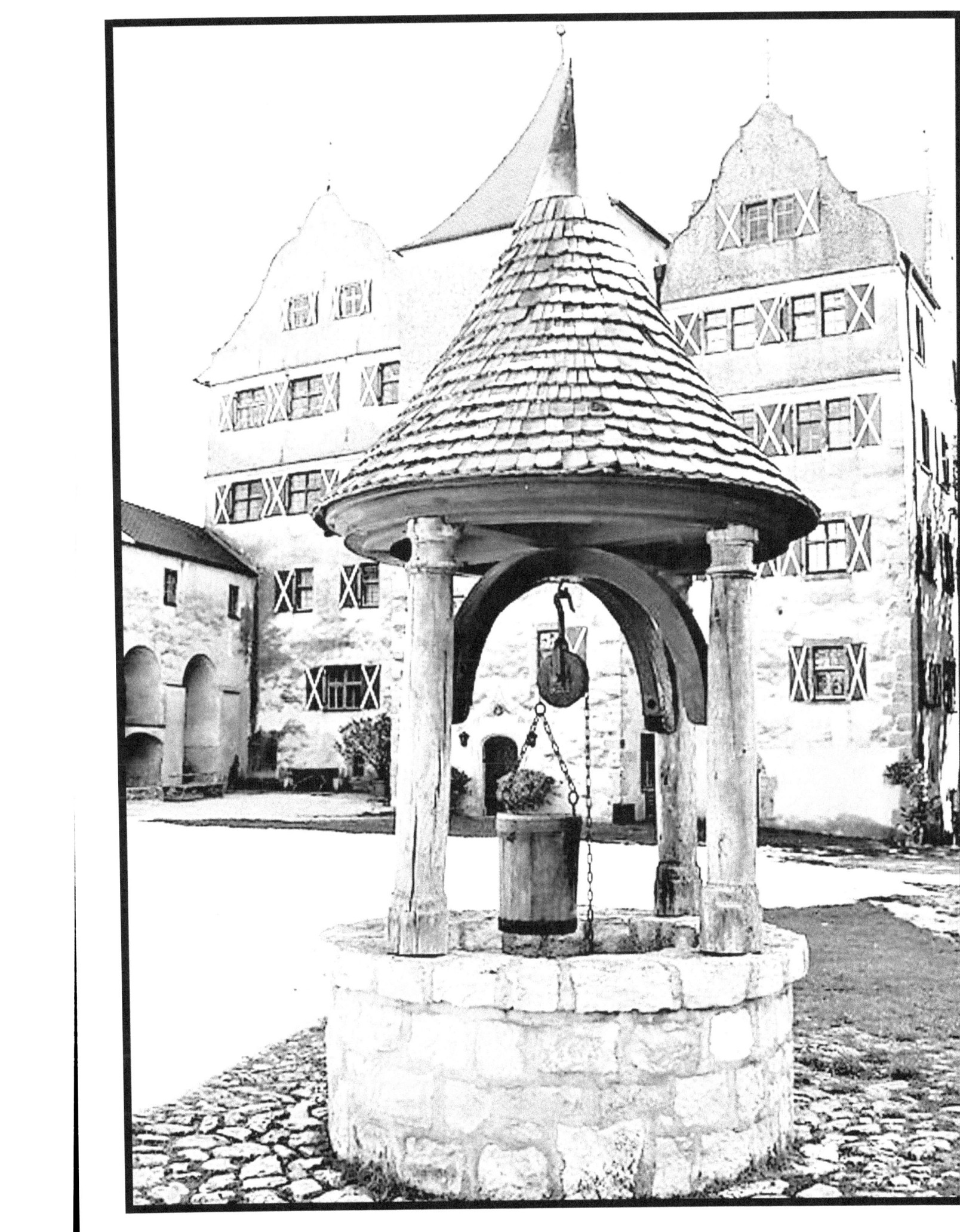

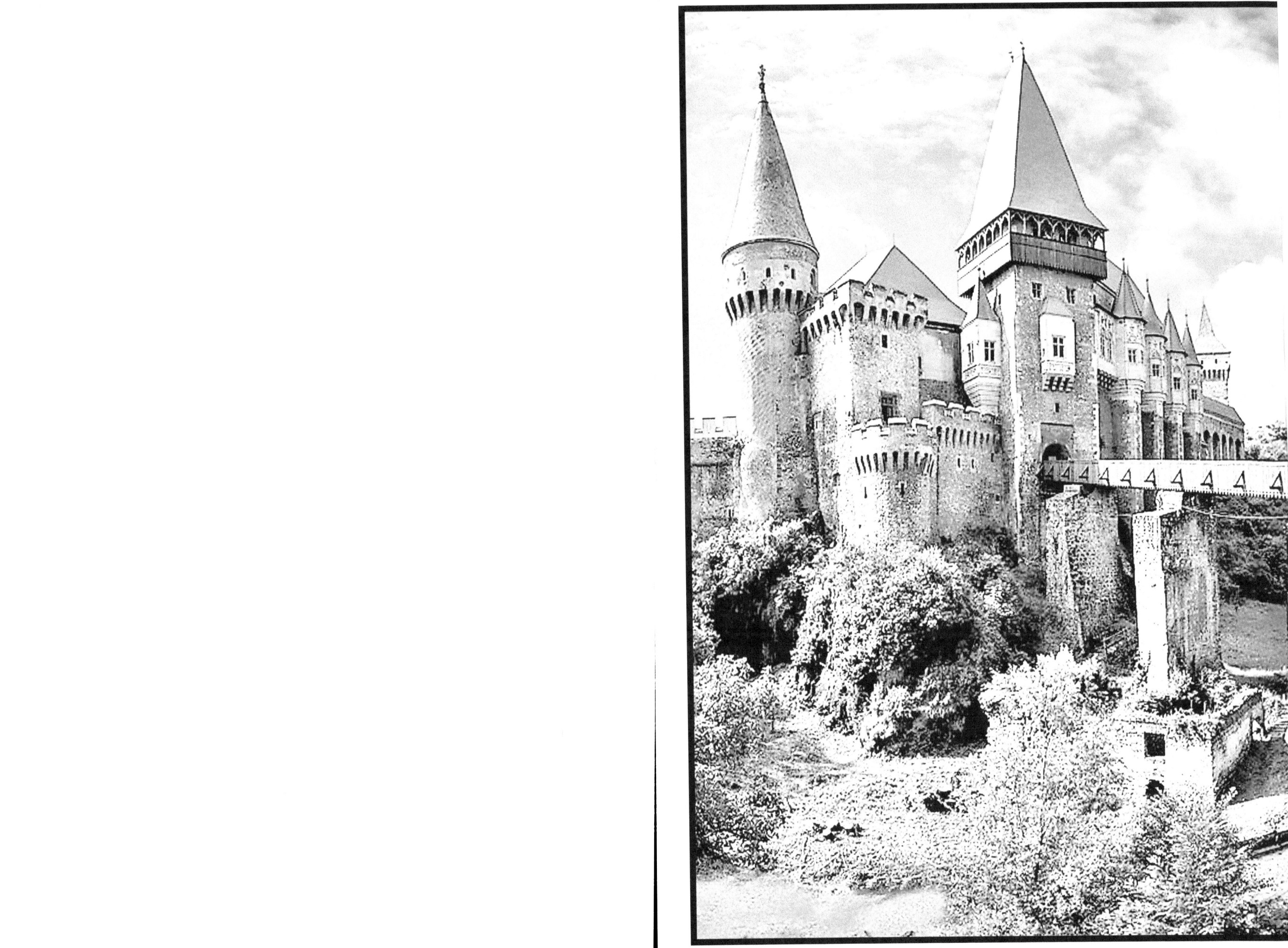

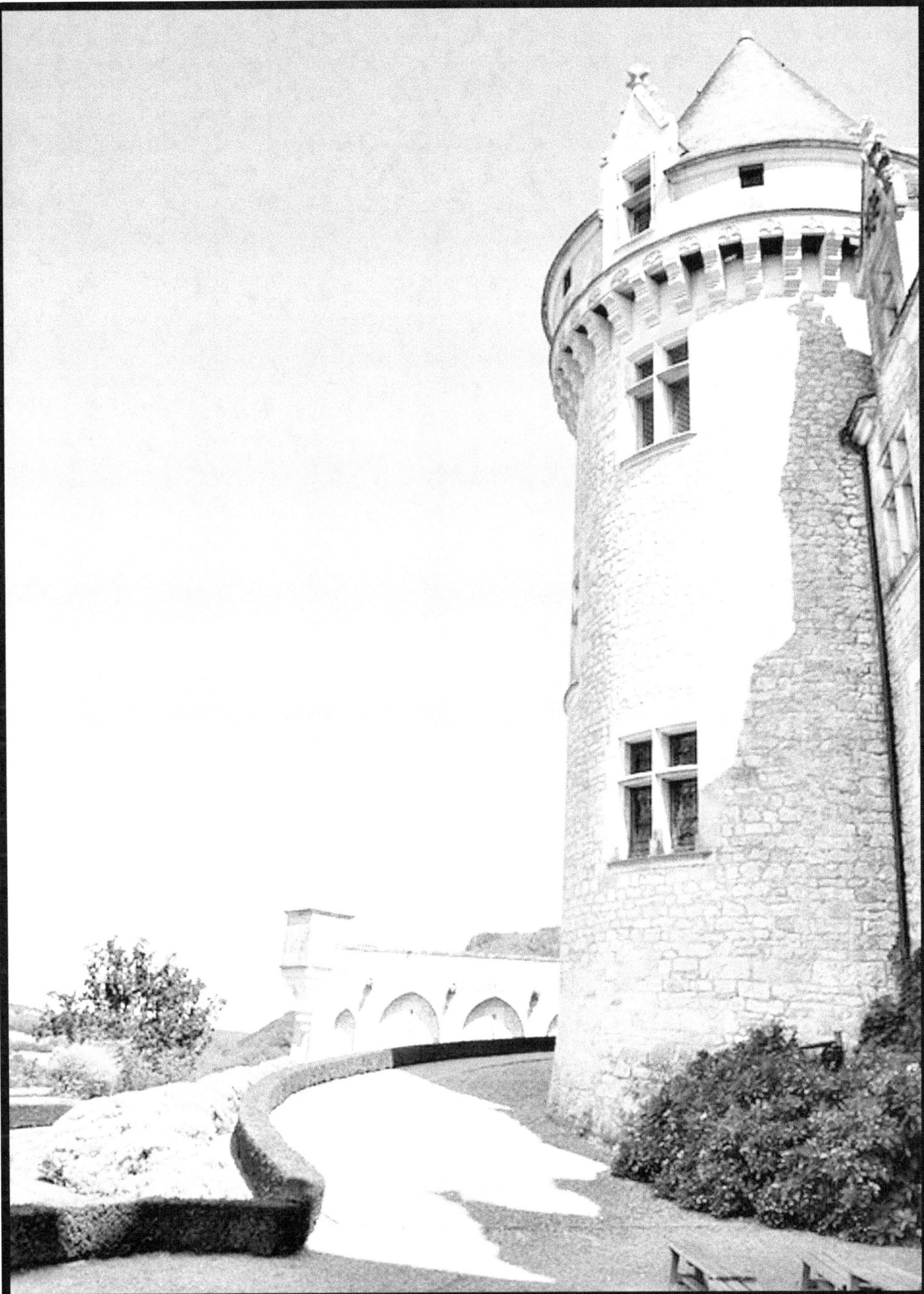

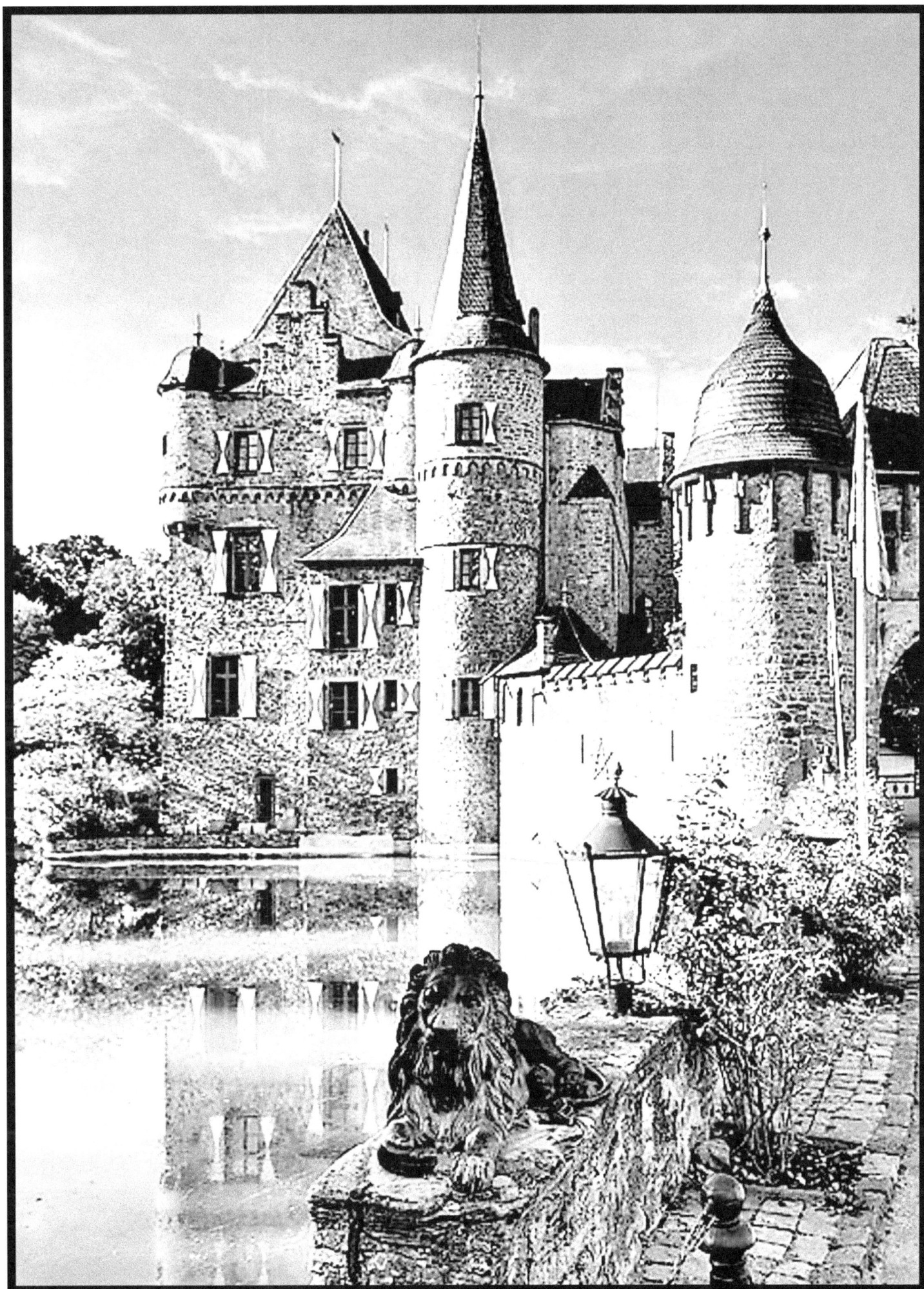

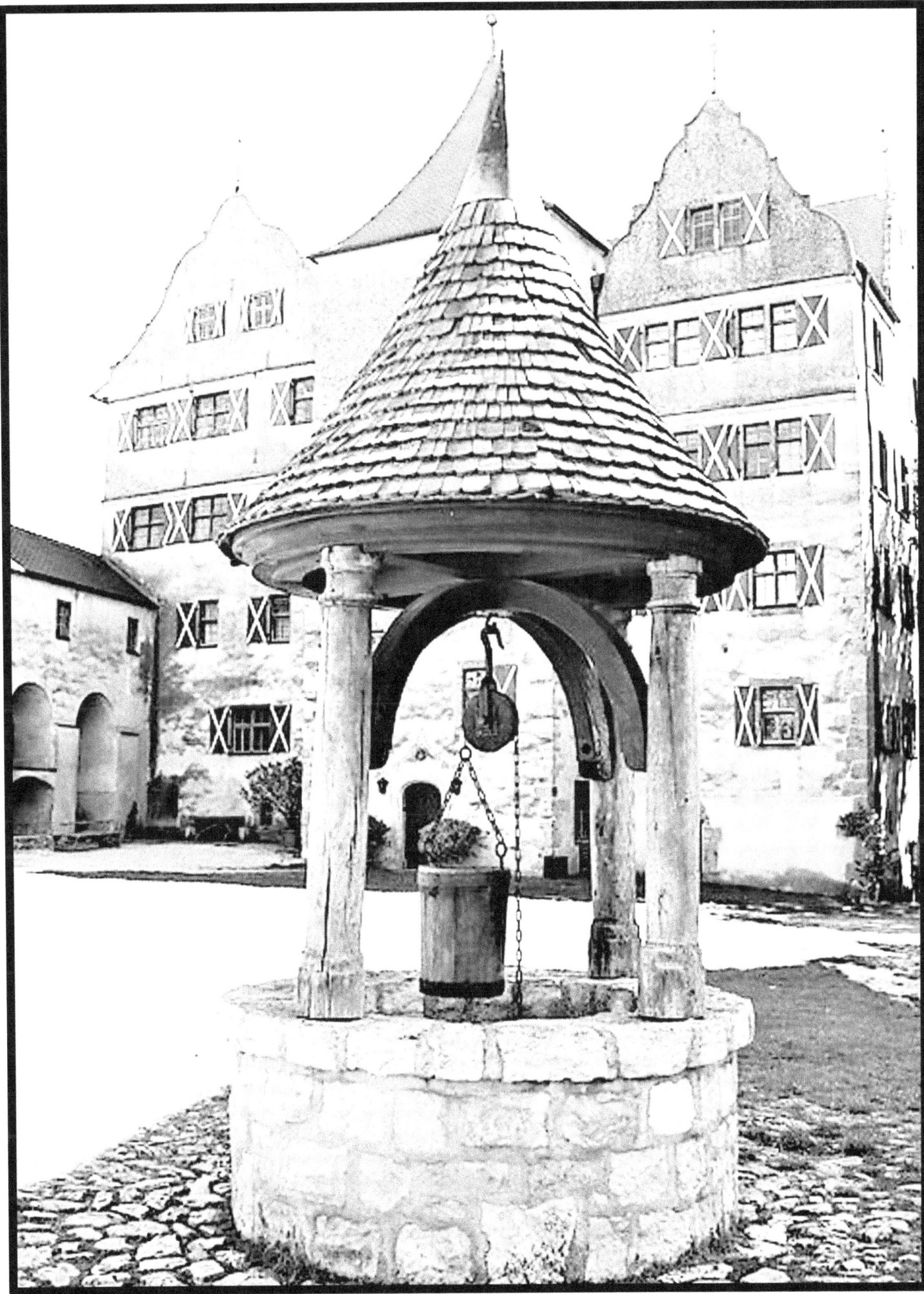

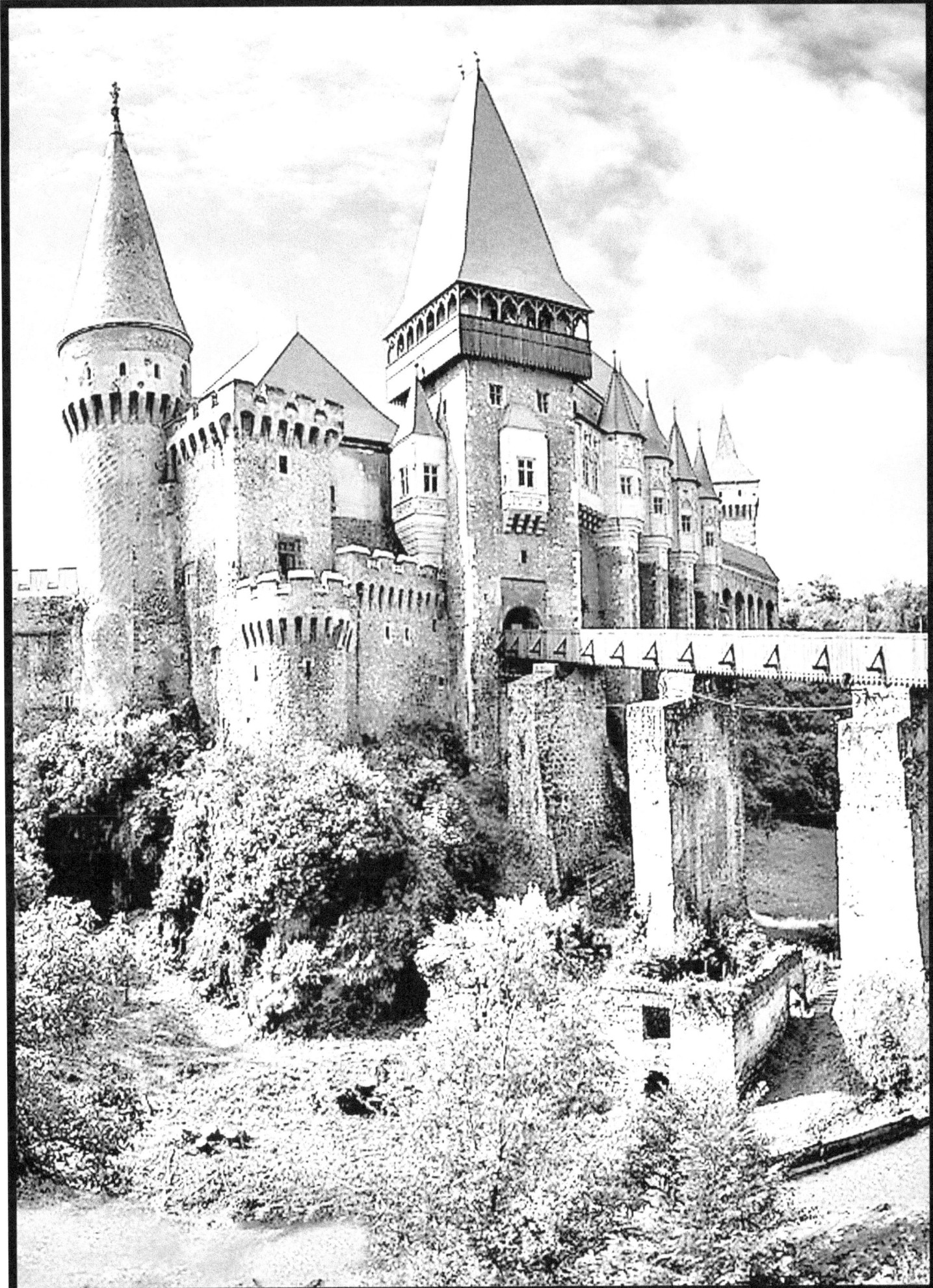

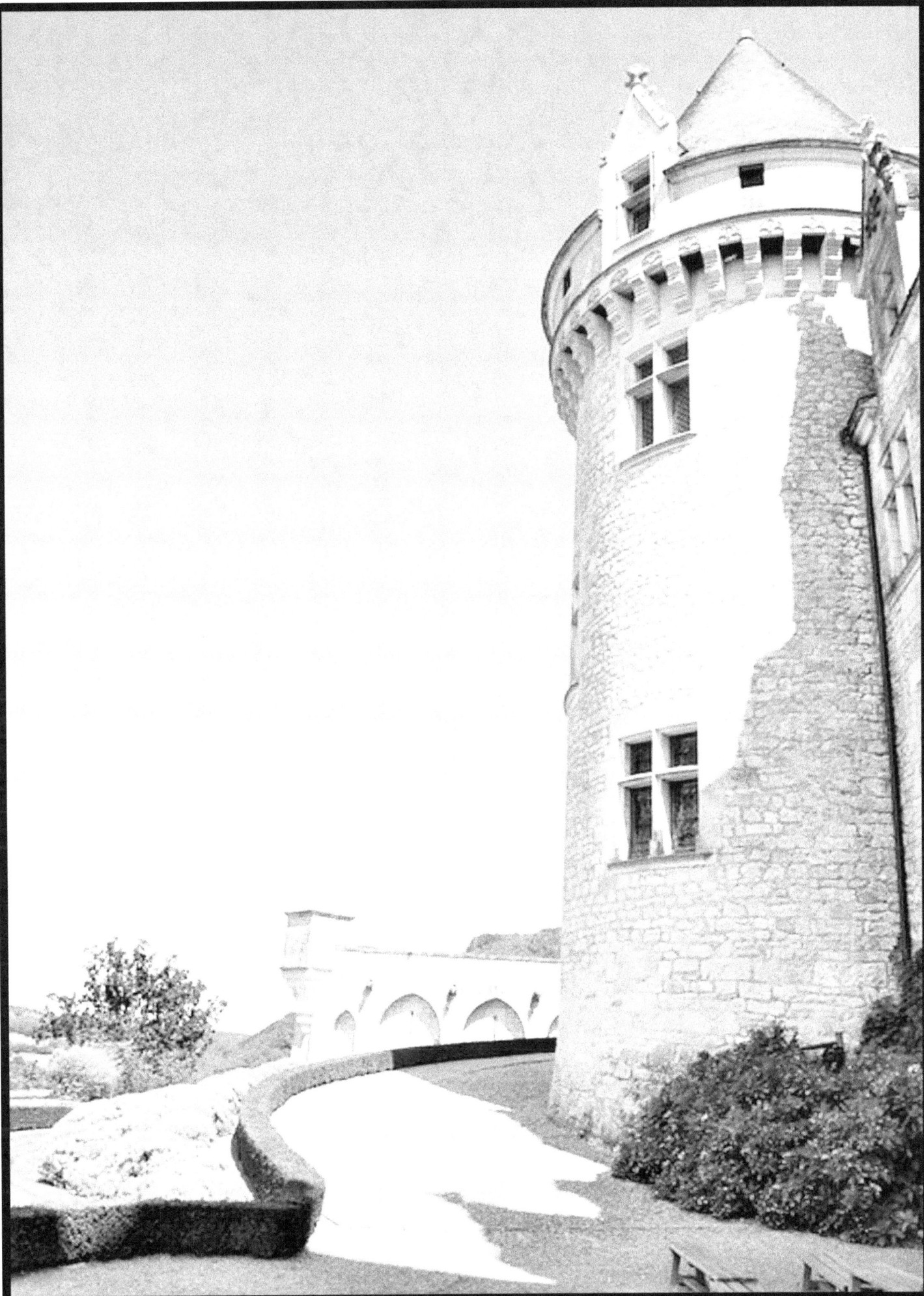

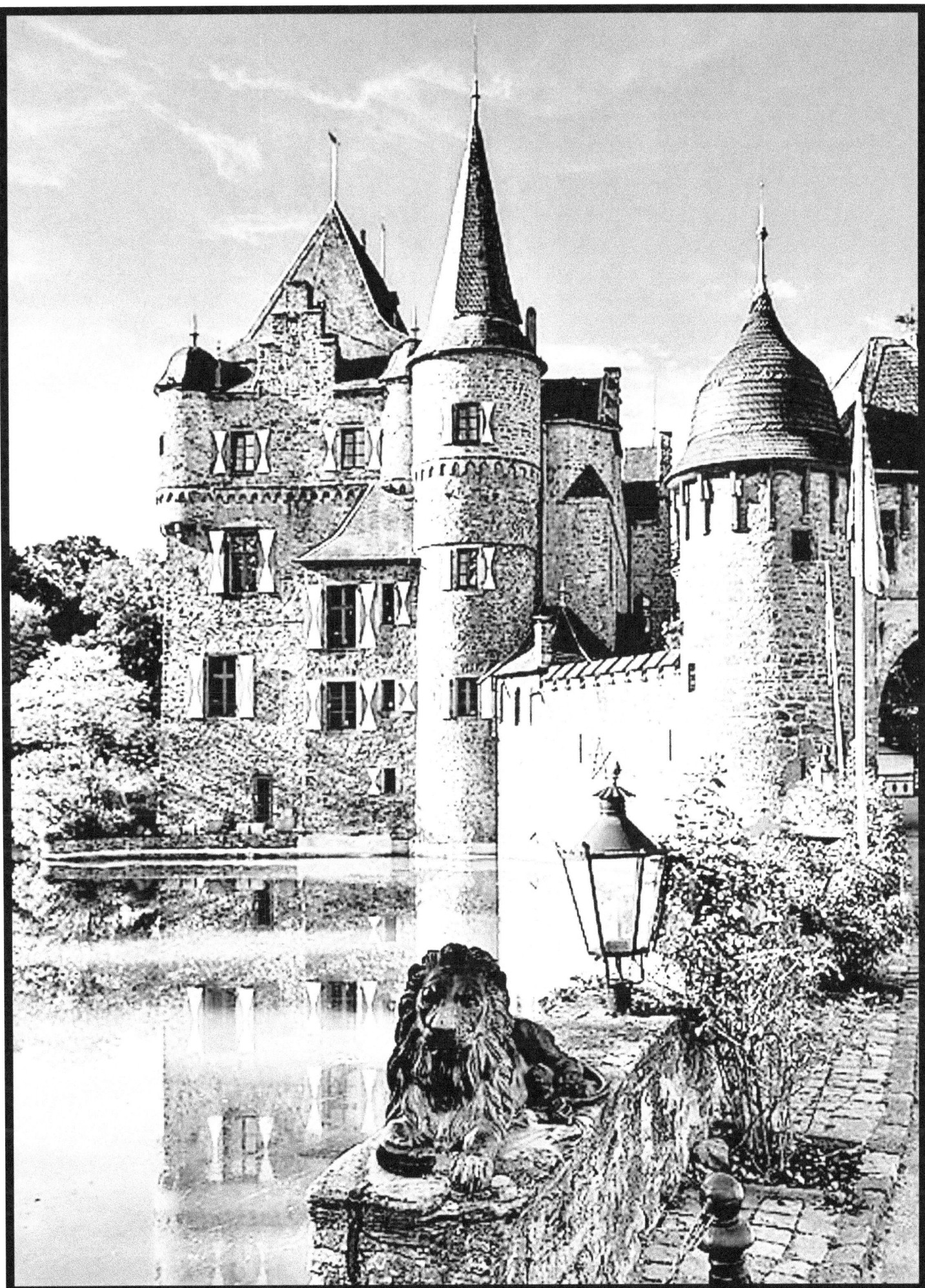

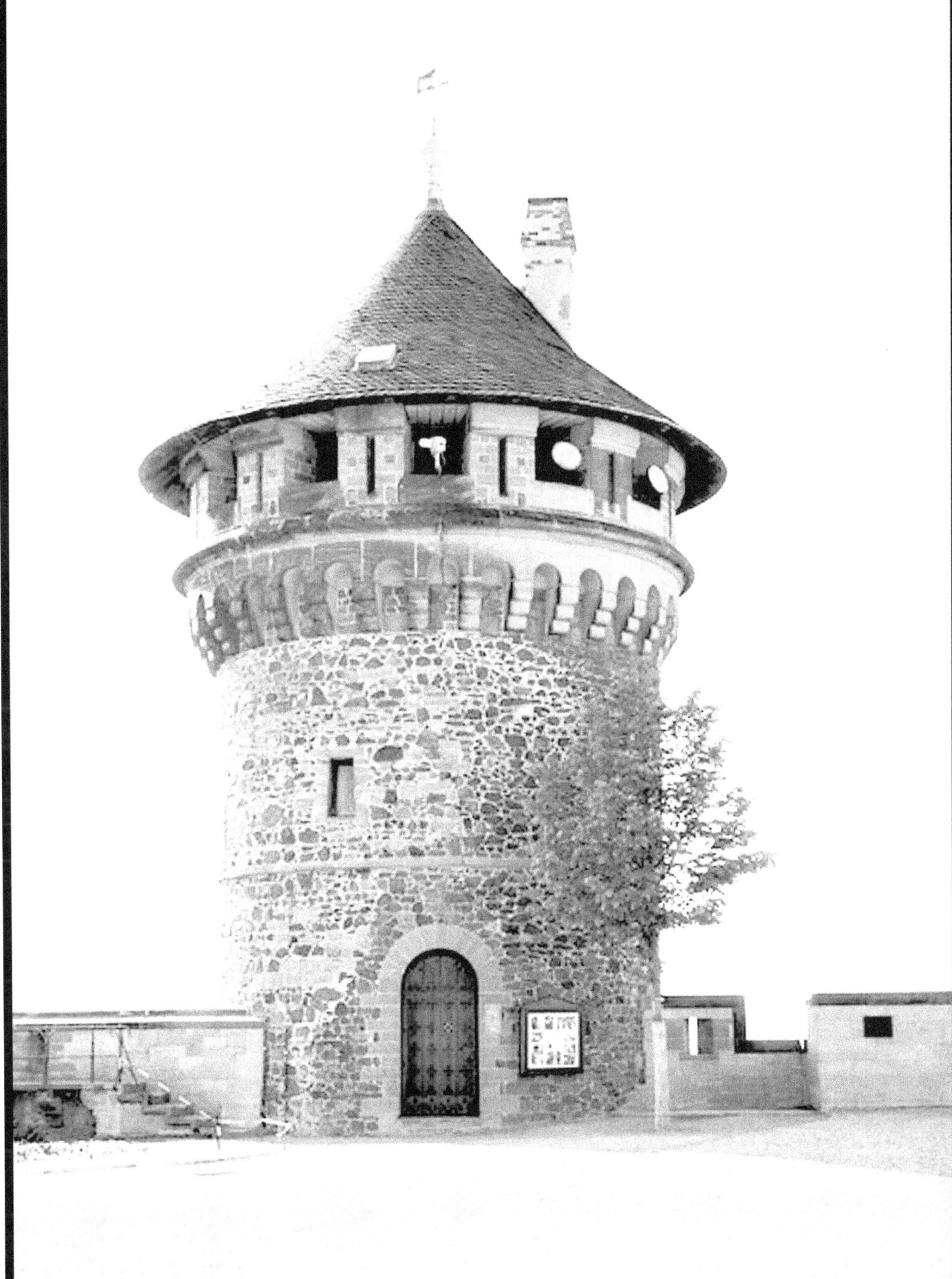

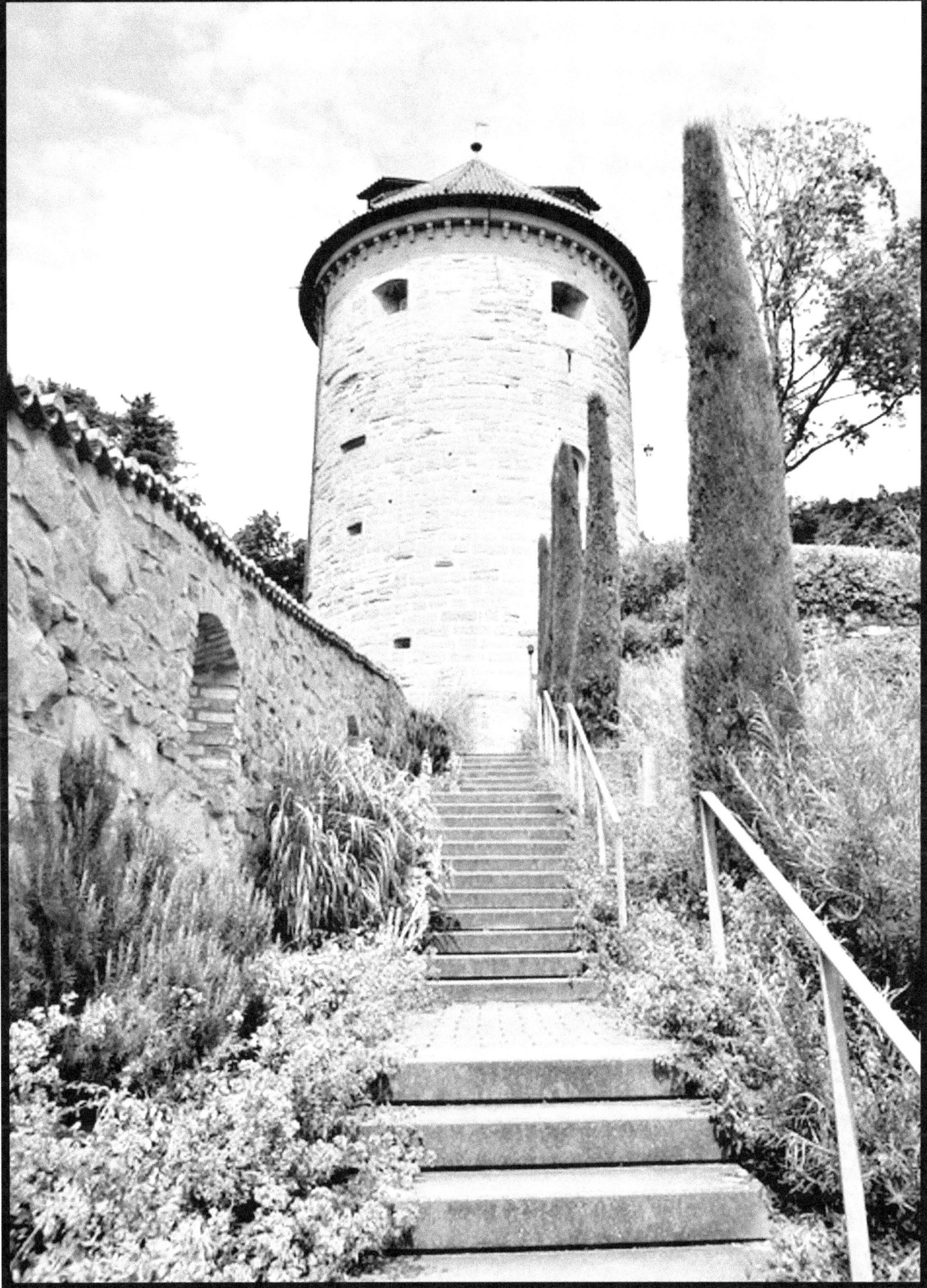

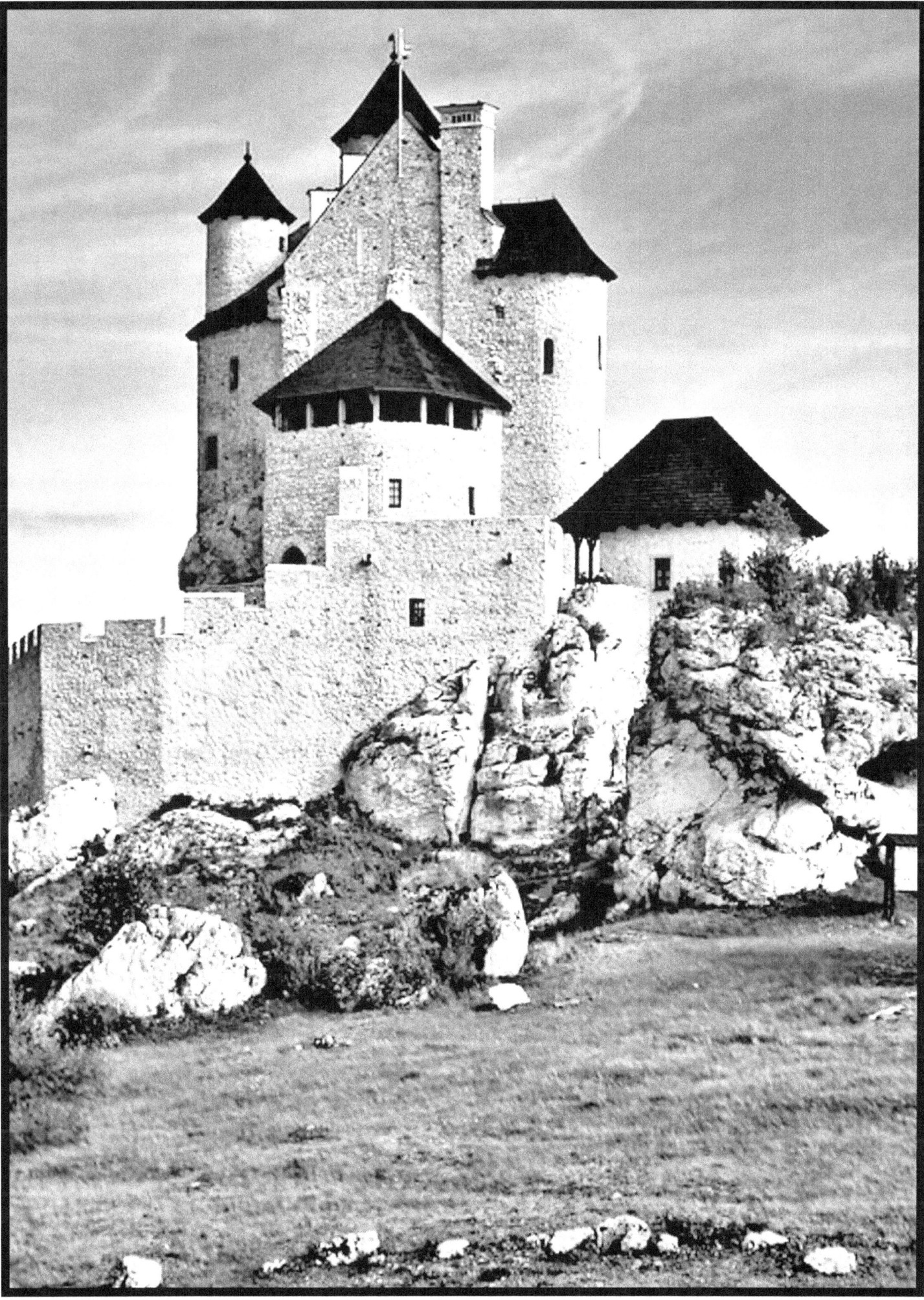

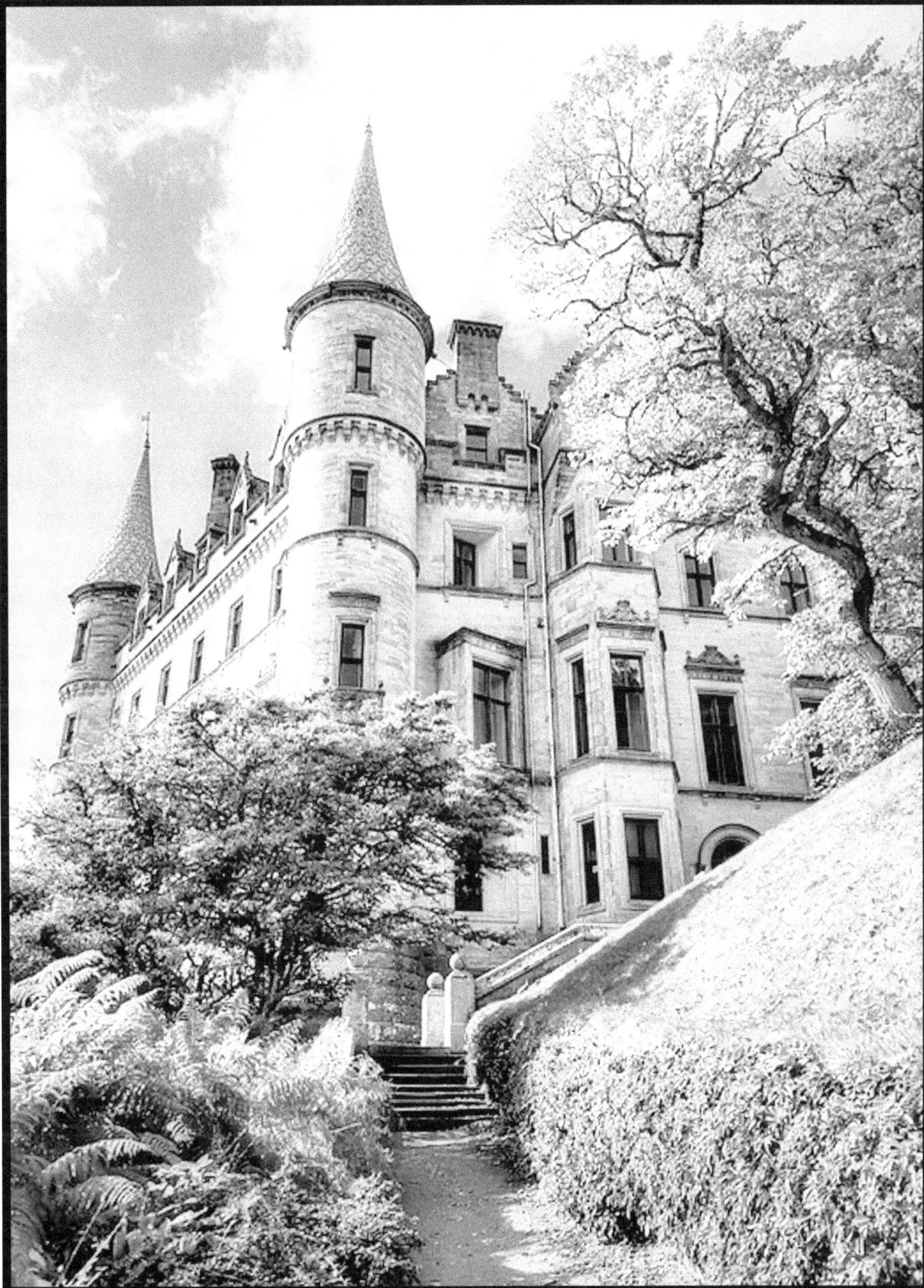

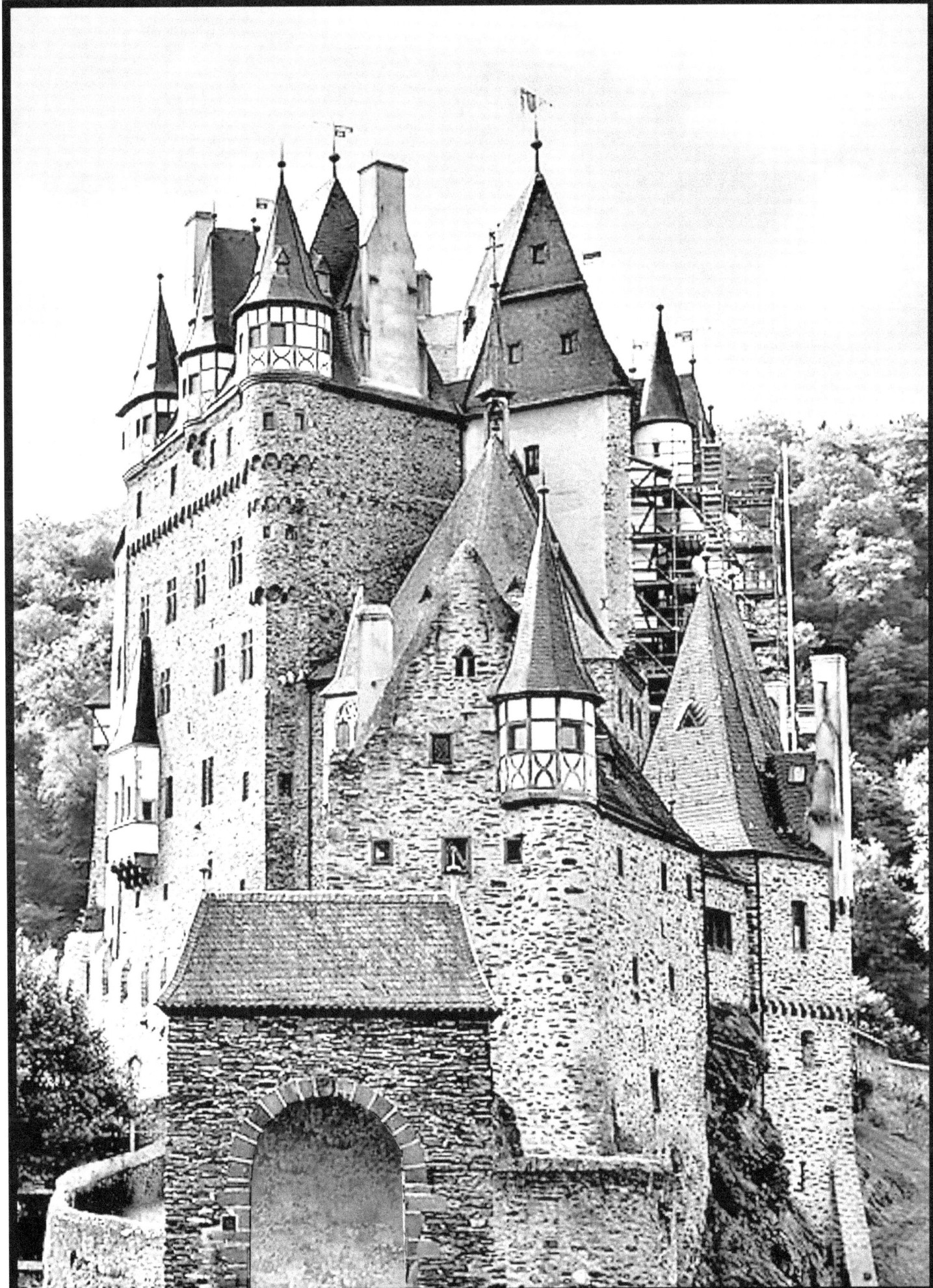

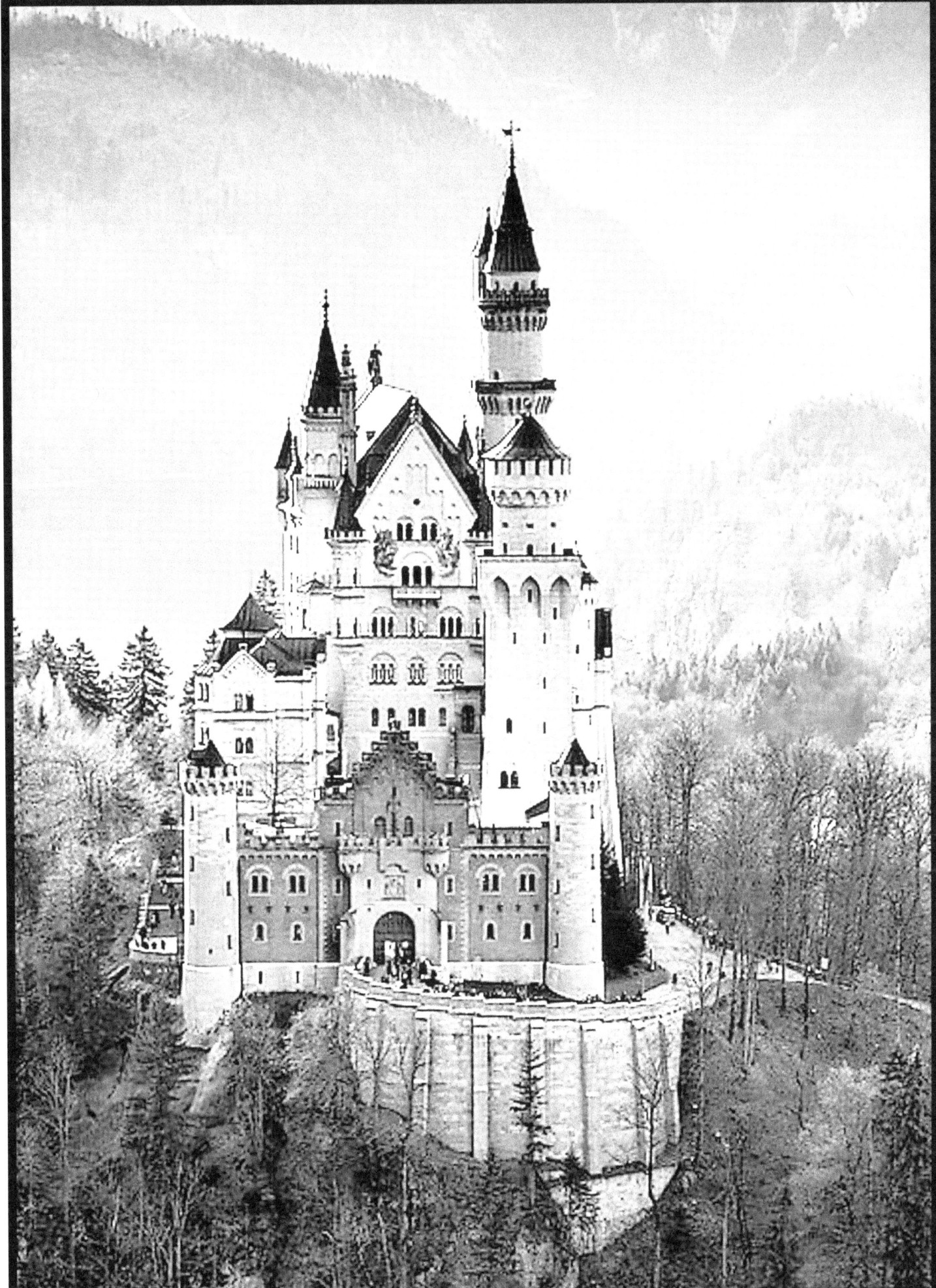

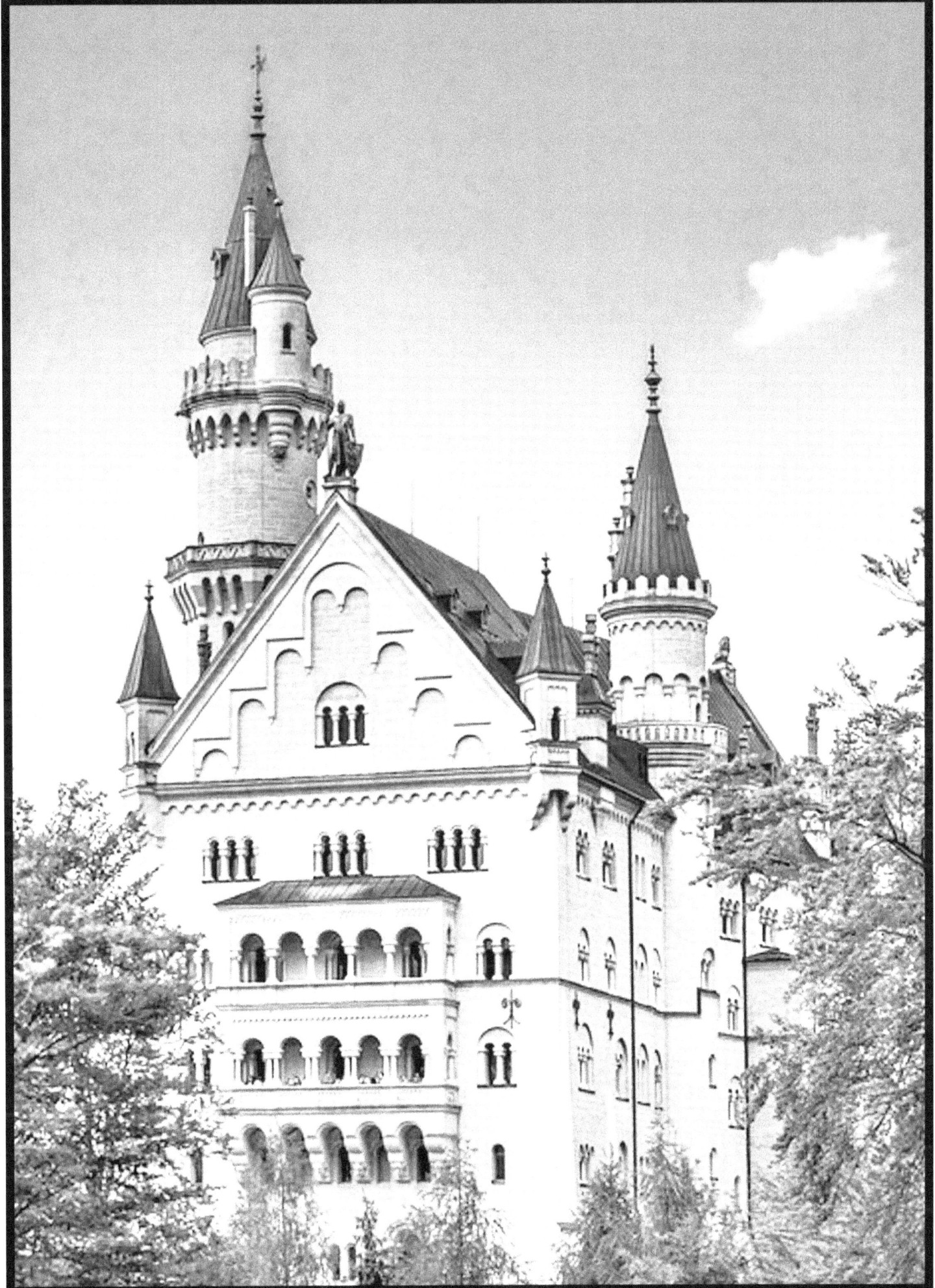

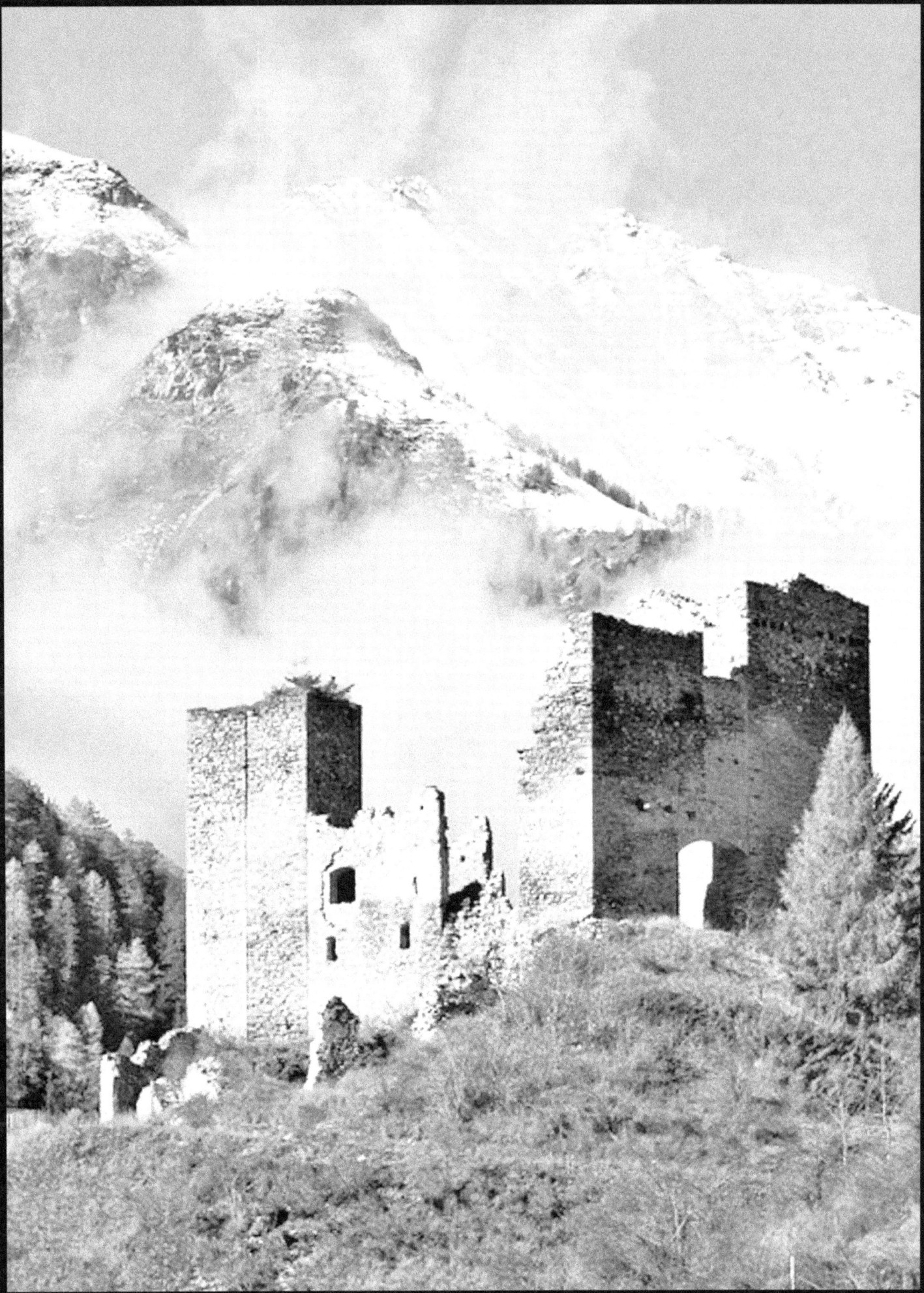

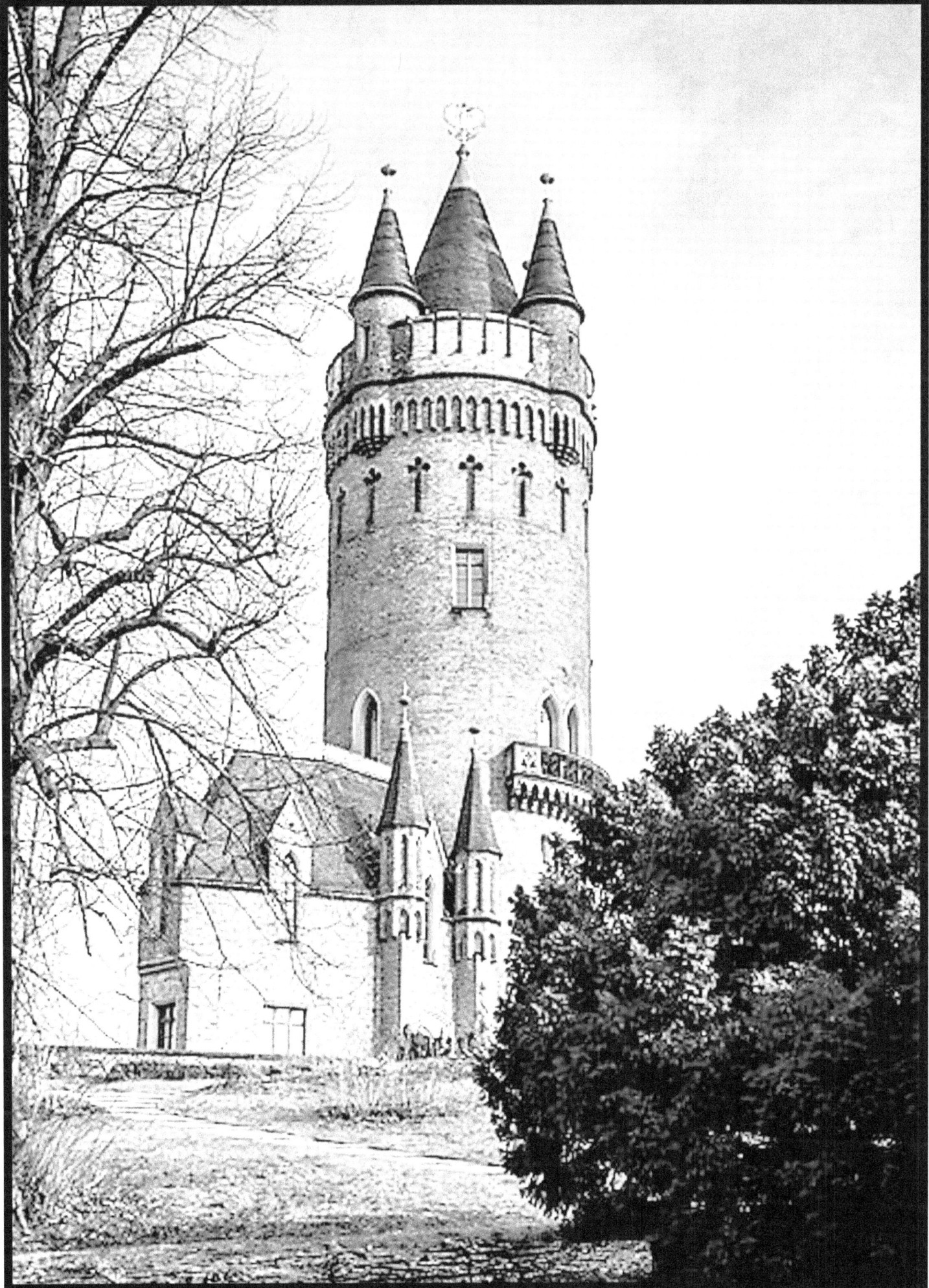

www.ingramcontent.com/pod-product-compliance
Lightning Source LLC
Chambersburg PA
CBHW082013230526

45468CB00022B/2127